MAKING HISTORY
Art and Documentary in Britain from 1929 to Now

D1464506

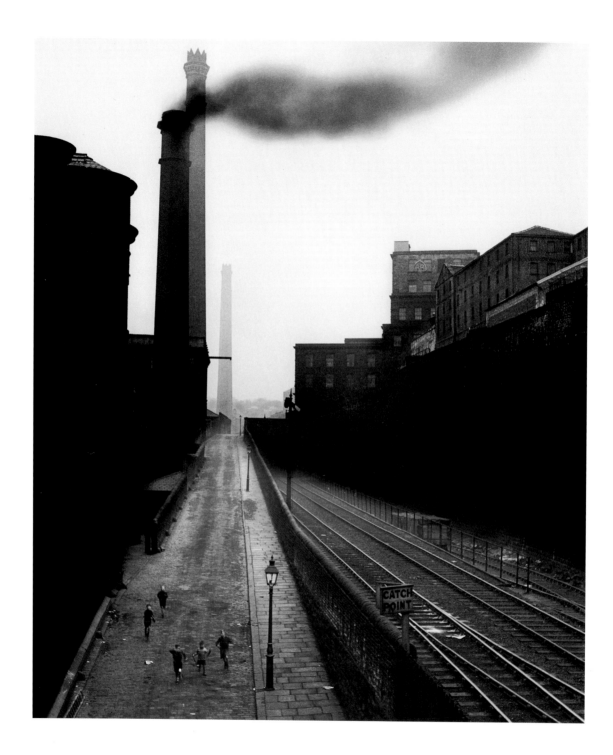

MAKING HISTORY

Art and Documentary in Britain from 1929 to Now

First published 2006 by order of the Tate Trustees
by Tate Liverpool Albert Dock, Liverpool L3 4BB

in association with
Tate Publishing, a division of Tate Enterprises Ltd,
Millbank, London SW1P 4RG
www.tate.org.uk/publishing
on the occasion of the exhibition

Making History:
Art and Documentary in Britain
from 1929 to Now

Tate Liverpool, 3 February – 23 April 2006

The exhibition at Tate Liverpool is supported
by Tate Members

© Tate 2006

British Library Cataloguing in Publication Data
A catalogue record for this book is available
from the British Library

ISBN 1-85437-682-9
ISBN 978-1-85437-682-4

Distributed in the United States and Canada by
Harry N. Abrams, Inc., New York

Library of Congress Cataloging in Publication Data
Library of Congress Control Number: 2006920120

Designed by Philip Lewis
Printed by Synergy Fine Colour Printers

Front cover: Roger Mayne *Southam Street,*
North Kensington 1959
Frontispiece: Bill Brandt *Halifax* 1937

Contents

Foreword

One of the principle concerns of contemporary art in recent years has been the manner in which we address and represent history. A return to the practice of documentary has formed part of that tendency and the broader discourse which has embraced questions of authenticity, truth, surveillance, evidence and reality. In this context, it seemed important to trace and examine the history of documentary itself, and the related field of social observation, and to focus on Britain where it has had such a significant and sustained presence. This is the first exhibition to survey this tradition in its entirety, charting its progress over eight decades. The exhibition, arranged in four chronological sections, will address the different concerns and approaches that arose at different times in Britain. It is not intended as a comprehensive survey of documentary but as a selective commentary encompassing work in a range of media, from different disciplines including painting, film and photography, video installation, television documentary and docudrama.

Representations of society at large, particularly in photography and film, have always had the power to fascinate. Through them we make a connection with the past, we examine our environment and our place within the social structure; we see our ancestors, our peers and acquaintances, we may even identify our selves at different moments during our life. Documentary, it is often supposed, holds a mirror up to society and our selves and similarly it is assumed that, like a mirror, it reflects the world with uncomplicated objectivity. This has led it to be credited with a greater authority and veracity than other modes of representation. Yet documentary takes various forms, not just in terms of the media it has used but also in the characteristics and components of its construction. Moreover, it is a form of mediation that is inflected by the motivations of the individual or group behind its production. For many years documentary has been undervalued as a genre, identified as a crude and formulaic mode of representation and often contrasted negatively with art or viewed as occupying a lesser terrain. This exhibition aims to demonstrate the strength and complexity of the documentary tradition in Britain, charting its development since the 1930s, as well as the instances of cross fertilisation between art and documentary practice.

Making History was curated by Tanya Barson, we are most grateful for the imagination and devotion with which she approached the subject and realised this exhibition. She was supported with skill and efficiency by Kyla McDonald, Darren Pih and Lucy Edwards.

This is a vast and important subject, which could not have been tackled without the generous help and advice from a wide range of people. In particular, the generous donation from Tate Members towards the exhibition. We also

acknowledge the support offered by Karen Alexander, Patrick Russell, Shona Barrett and their colleagues at the British Film Institute which has been invaluable. We would also like to thank those who have encouraged and helped to facilitate this project, most particularly Fiona Salvesen at Bolton Museums, Art Gallery and Aquarium; Stephen Garside at Manchester Metropolitan University; Pete James at Birmingham Central Library; Mike Seaborne at the Museum of London; Murray Martin at Side Gallery, Newcastle; Mike Sperlinger at LUX, London; Susan May at the Arts Council Collection, London; Roger Tolson at the Imperial War Museum, London; Gill Henderson and Karen Allen at FACT, Liverpool; Mark Sealy and Indra Khanna at Autograph-abp, London; Emma Chambers at UCL Art Collections, London; Chris Stephens at Tate Britain, London; Tamara Dial at Marlborough Fine Art, London; Stephanie Camu at Haunch of Venison, London; Andrew Hamilton at the Modern Institute, Glasgow; Tom Dingle at Artangel, London; Augusta Ogilvy at the Mayor Gallery, London; Anthony Reynolds at Anthony Reynolds Gallery and Patrick Henry at Open Eye Gallery, Liverpool. My thanks also goes to all the artists, museums, galleries and institutions who lent works and who helped with advice and assistance. Among the artists, particular thanks goes to Roger Mayne, Vanley Burke and Carey Burke, John Davies, Sirkka-Liisa Konttinen, Rita Donagh, Chris Killip, Humphry Trevelyan, William Raban, Horace Ové, Isaac Julien, Jeremy Deller and Nathan Coley. Kind permission to include key material has been granted by the British Film Institute, the Royal Mail Film Archive, Granada International, Film Images, Paul Watson and Philippa Donnellan.

I would like to thank Lynda Morris, Mark Nash and David Campany for contributing fascinating and insightful essays to the catalogue. I would also like to thank Philip Lewis for his arresting and sensitive design of the catalogue. In addition we are grateful to Jemima Pyne, Larissa Kolstein and Helen Tookey for producing this publication with skill and dedication, and to Maria Percival and Laura Britton for their work on the interpretation and education. As ever, huge thanks also go to the Tate conservators, particularly Tina Weidner, Jo Gracey and Mary Bustin, as well as to Ken Simons, Wendy Lothian, Barry Bentley and Stephen Gray for their work towards realising the exhibition.

I am delighted that Tate Liverpool will present an exhibition of this scale and ambition, giving audiences an opportunity to see the breadth and importance of the engagement between art and documentary in Britain over so many years.

Christoph Grunenberg
DIRECTOR

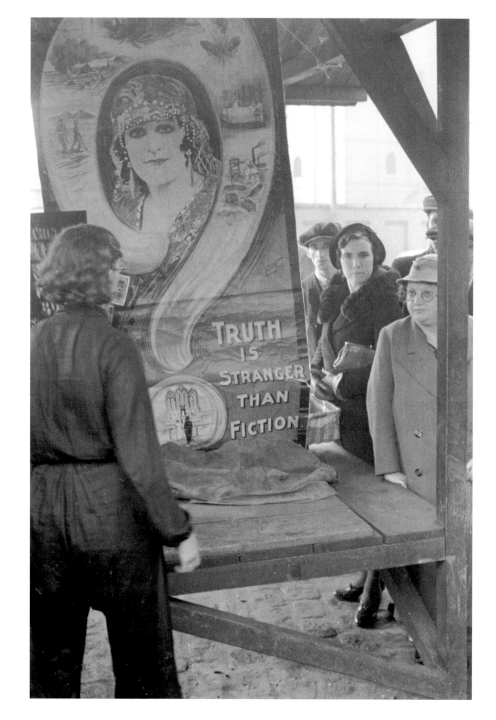

Time present and time past

The choice of the
documentary medium is
as gravely distinct a
choice as the choice of
poetry instead of fiction.

JOHN GRIERSON[1]

TANYA BARSON

The resurgence of documentary forms in contemporary art and the
concern with historiography, the writing of history, provides one
motivation for examining the history of documentary practice in
Britain. Documentary in Britain was established during the 1930s as
a film movement led principally by the director, producer and writer
John Grierson (1898–1972), who was also one of the first to provide
a definition and theory of documentary.[2] Through this movement
Britain played a central role in the development of documentary; from
the beginning artists were involved and made crucial contributions.
In turn, artists have been influenced by documentary practitioners.
The traditional opposition between art and documentary can there-
fore be considered a false dichotomy. This exhibition presents a
survey of the impact of documentary practice on British art and
artists, and vice versa, encompassing film, photography, painting
and installation. It focuses, not on all documentary productions, but
on those areas where a dialogue between art and realist documentary
occurs. The exhibition aims to question the accepted understanding
of the parameters of documentary, as well as to confront some of the
principal issues surrounding documentary. Among these, and critical
to any understanding of documentary practice, is the impact of the
politics of social observation: the position of the author/observer and
their relationship to the observed, who is frequently located in a site

Humphrey Spender *Open
Market – Palmist* c.1937–8

9

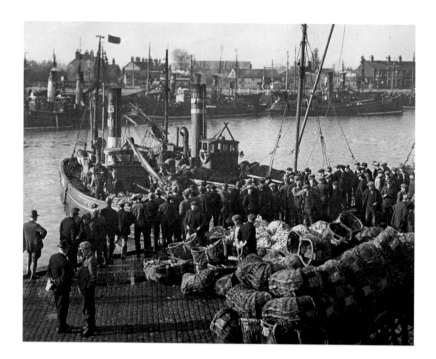

John Grierson
Drifters 1929

of social or cultural alterity; the questioning of the authority of the document, the indexical character of film and photography and their designation as 'transparent' and objective media; the relationship of the real to empirical appearance; and the links between documentary practice and avant-garde Modernism.

'A new and vital art form'

John Grierson was the first to apply the term 'documentary' to visual media.[3] Grierson was to become the chief architect of the documentary film movement in Britain, working initially as a director, occasional cameraman and editor, but later primarily as a producer and writer, first at the Empire Marketing Board Film Unit and then at the General Post Office (GPO) Film Unit. As producer, he brought together an extraordinary group of practitioners from various disciplines (among them Humphrey Jennings, Benjamin Britten and W.H. Auden) and persuaded important figures from overseas (including Robert Flaherty

Tanya Barson

and Alberto Cavalcanti) to work in Britain, giving the movement an international dimension. Among his 'first principles' of documentary Grierson stated, 'We believe that the cinema's capacity for getting around, for observing and selecting from life itself, can be exploited in a new and vital art form.'[4] Grierson sought to establish a national cinema founded on principles of social purpose and education, but which nevertheless utilised the creative capacity of the medium for the purpose of depicting reality. However, Grierson did not advocate the straight transcription of reality; though committed to naturalism he employed the idealist distinction between the real and the phenomenal, and stressed the need to creatively interpret reality through symbolic expression.[5] His principal legacy is often felt to be the anti-aesthetic definition of documentary as the objective representation of fact that characterises journalism and reportage. While he was certainly 'opposed to "over-aestheticization" and . . . to excessive formalism', the story is, arguably, more complex.[6] His writings and his films reveal a different picture, one that positions his work in dialogue with the avant-garde.[7]

Grierson's film *Drifters* 1929, a silent documentary about the North Sea herring fleet, was a critical and commercial success.[8] It contains many of the traits that would later typify documentary but was also influenced, for instance in its use of montage, by Modernist film, particularly Walther Ruttman's *Berlin: Symphony of a City* 1927 and the work of Russian filmmakers, including Sergei Eisenstein. For Grierson, it was Russian cinema, particularly the work of Alexander Dovzhenko, which provided the best example of the representation of reality. *Drifters* was an attempt to create an 'imagist' film in response to the avant-garde 'city symphony' films and to reintroduce socially directed commentary into formalist film.

The documentary movement of the 1930s arose in the context of the broadly socialist politics of the Popular Front. With the Wall Street Crash in 1929 and the Depression, artists, writers, photographers and filmmakers became increasingly politicised and focused attention on working-class subjects and themes of social inequality. The painter William Coldstream explained that 'the 1930s slump affected us all very considerably. . . it caused an immense change in our general outlook. . . Everyone began to be interested in economics and then in

politics'.[9] By the low point of the financial decline in 1933–34, Coldstream was finding it difficult to sustain a living as a painter and had become troubled by the inaccessibility of avant-garde painting to a general audience. Exchanging painting for film, which had greater potential for mass communication, he began working at the GPO Film Unit. There he made a number of short films and collaborated with Alberto Cavalcanti and W.H. Auden on *Coalface* 1935, which exemplifies Cavalcanti's non-naturalistic approach to factual cinema, blending poetry and realism. When Coldstream did return to painting, it appears that Grierson's sense of social purpose and concern with realist documentary influenced him to seek a more precise method for representing reality, founded on observation.[10] Coldstream developed his ideas about realism through the teaching of the Euston Road School, which he co-founded in 1937. The members of the school became the principal advocates of realism and direct observation in art, defending their position in March 1938 in a debate that set Realism against Surrealism. In 1949, Coldstream transferred his commitment to realism to the Slade School of Art, where he was appointed professor.

Coldstream had also participated in Mass-Observation. Founded in 1937 by the anthropologist Tom Harrisson with Charles Madge and Humphrey Jennings, Mass-Observation sought to examine and document working-class lives. Yet it involved a complex combination of sometimes contradictory ideas, motivations and methods; it also attracted artists on both sides of the Realist vs. Surrealist debate. In both Spender and Trevelyan's Mass-Observation photography a Surrealist preoccupation with the eccentric or bizarre frequently supplants the role of objective social document. Mass-Observation constituted both a form of self-ethnography and an examination of social alterity. It was, as David Mellor has explained, a 'recoil from Europe' towards 'the exploration of the unknown British interior, already made foreign by the ravages of the Depression, distanced by class barriers and thereby populated by a "race apart"'.[11]

Bill Brandt is known as the 'great documentarian' of British life, committed to social commentary and social equality, yet he also epitomises the artist-photographer. He too was well versed in Surrealism. His photography of the industrial North occupies a

Tanya Barson

particular and pivotal place in the history of British social observation. Yet his work of the 1930s and 1940s involved both forceful, realist documentary, which exposed the class stratification of English society and the effects of industrialisation, and dramatic, staged realism using stand-ins, set in the moonlit streets of London. In 1940, Brandt worked briefly for the Ministry of Information taking photographs of the underground shelters which appeared in *Lilliput* alongside Henry Moore's drawings.[12] Thus Brandt's work occupies apparently conflicting territory and confronts the divisions between the fields of documentary, art and propaganda, employing strict observation combined with avant-garde creativity and fictitious devices. Brandt can be contrasted with other, more actively political, though less experimental émigré photographers. Paul Delany comments on how 'Edith Tudor Hart's career had in several ways run parallel to Brandt's up to 1940. . . but the similarities between her pictures and Brandt's also suggest how photographs of the "same" subject may differ fundamentally in spirit'.[13] Edith Tudor-Hart (née Suschitzky), an Austrian émigrée who married an Englishman, worked for the Comintern throughout the 1930s and 1940s and produced powerful, socially committed photographs which were frequently used for political purposes.[14]

With the outbreak of World War II, many of the artists and practitioners who had been involved in documentary projects during the 1930s were co-opted into official bodies for the creation of propaganda. The GPO Film Unit became the Crown Film Unit and part of the Ministry of Information. Humphrey Jennings, who made his best known films at this time, stands out among the documentary filmmakers of the period as, arguably, the one who has exerted the greatest influence on subsequent generations; he has been called 'the only real poet the British cinema has yet produced'.[15] Jennings's experimental work, such as *Listen to Britain* 1942, challenged easy definitions of documentary through his use of associative montage, combining filmed images, music and poetry. With the development of increasingly sophisticated propaganda imagery, especially films with the subtlety of Jennings's wartime productions, a simplistic view of the impassive objectivity of the camera became ever more questionable.

Looking at Britain

During the 1950s and 1960s hybridisation in film and television, involving factual treatment of fictional stories, became a way to address key social issues as well as to examine concepts of national identity. Launching the Free Cinema movement in 1956, Lindsay Anderson wrote, 'Our aim is first to look at Britain, with honesty

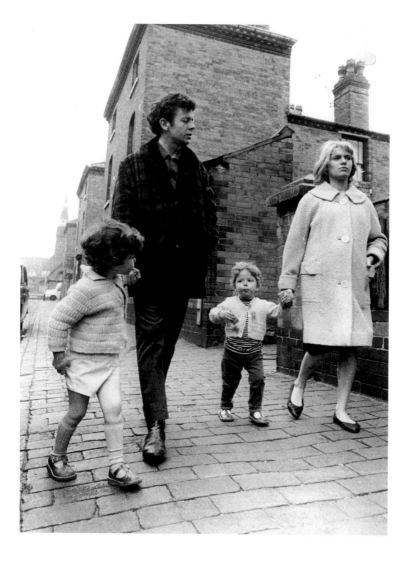

Ken Loach
Cathy Come Home 1966

and with affection. To relish its eccentricities, attack its abuses, love its people. To use the cinema to express our allegiances, our rejections, and our aspirations. This is our commitment.'[16] The concern of this group of filmmakers, including Anderson, Tony Richardson, Karel Reisz and Lorenza Mazzetti, was to look at 'the whole of Britain.'[17] Anderson's documentary film *Every Day Except Christmas* 1957 and Reisz's *We Are the Lambeth Boys* 1959 demonstrate the intention of Free Cinema to present an unscripted and unmediated view of working-class lives.[18] The Free Cinema directors brought the everyday realism and 'angry young men' of the kitchen-sink dramas from the theatre and novels to the screen.[19]

Fictional films such as Reisz's *Saturday Night and Sunday Morning* 1960 and Richardson's *A Taste of Honey* 1961 shared the kitchen-sink aesthetics and realist documentary style of the earlier films, achieved through Walter Lassally's location cinematography, the concentration on social themes, casting of unknown actors and limited use of extras. Ken Loach's television docudrama about homelessness, *Cathy Come Home* 1966, exemplifies the mixing of drama with documentary material, methodical research and stylistic devices (deriving immediacy from action-led camera) to address social problems; it contributed decisively to the debate about the power of television in raising public awareness and the ambiguities surrounding such hybrid forms, including questions of truth and partiality. In the 1960s, the advent of television docudramas, documentaries and regional soap operas effected a dissemination of documentary realism through popular culture. Granada chairman Denis Forman was instrumental in commissioning the *World in Action* series that began with *7Up* in 1963. At Granada, Michael Apted worked on early episodes of *Coronation Street* and as a researcher on *7Up*, before being encouraged by Forman to continue the groundbreaking documentary series.[20]

In painting, the lines were re-drawn between two opposing conceptions of realism: Modernist realism and 'kitchen-sink' realism, and their respective advocates, the critics David Sylvester and John Berger. Sylvester was invited by Coldstream to join the faculty of the Slade, as was one of the principal artists championed by Sylvester, Lucian Freud. Modernist realism, formulated in relation to phenomenology and existentialism, emphasised a non-narrative structure. Freud

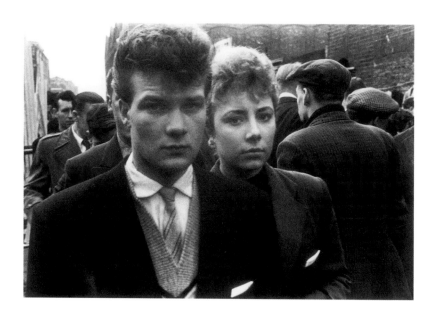

developed a stylistically meticulous brand of realism, exemplified by works such as *Interior in Paddington* 1951, representing mundane and quotidian details of the physical world while alluding to the nature of existence and the metaphysical. Michael Andrews' painting *People on the Beach (August for the People)* 1951, based on lines by W.H. Auden, reflects Coldstream's teaching of realism based on meticulous factual notation and Andrews' fascination with observing human behaviour.[21] In contrast to Sylvester, John Berger supported a group of artists, including John Bratby, Derrick Greaves, Edward Middleditch and Jack Smith, who were concerned with social realism and concentrated on unheroic depictions of the every-day in still life, landscape and industrial scenes, as well as Prunella Clough, who painted images of industry and labour. Support of these socially concerned, figurative artists reflected Berger's position as an independent Marxist critic. Bratby exemplifies the garish colours and bold, painterly technique employed by the 'kitchen sink' group; *Still Life with Chip Frier* 1954 portrays domestic disorder while *The Toilet* 1955 represents an extreme depiction of raw reality and basic living conditions.

Tanya Barson

In photography, Nigel Henderson and Roger Mayne focused on the extraordinary and unexpected in the everyday. Henderson was well acquainted with Mass-Observation photography; from 1949 to 1953 he took many photographs of Bethnal Green, focusing on the surreal and ritualised aspects of street life, including the Coronation celebrations.[22] Similarly, Mayne, a friend of Henderson's, spent five years photographing Southam Street in London. David Sylvester, reviewing Mayne's ICA exhibition in 1956, characterised him as 'what used to be called an "objective reporter", taking his subjects from the London streets and showing them to us with subtle understanding'.[23] Yet Mayne did not see his work as fitting neatly into the social realist tradition; while committed to objective observation he argued against a 'preconceived moral or political standpoint'. He commented, 'Southam Street is too extraordinary to be typical – the photographs are a dramatisation rather than a portrayal of a slum street'.[24]

Gender, race and society

Feminist and black artists and filmmakers during the 1970s and 1980s used, and frequently subverted, documentary modes and conventions in order to address, respectively, the role of women in society and the construction of a multicultural image of Britain. The place of female artists and black artists outside the accepted framework of history often prompted them to adopt sociological or documentary practices to give weight and seriousness to their arguments (through the presentation of 'evidence'), or, conversely, to challenge documentary practices from within, revealing apparently objective representation as a construction, and one that derived its bias from the prevailing hierarchies and power relations within society. Since documentary had often focused on observing those marginalised in terms of economic relations (the working classes) or cultural identity (race or gender), it was particularly effective in addressing the politics of alterity. By adopting documentary forms black and women artists were able to critique the framework of representation and signification embodied in documentary.

Margaret Harrison, Mary Kelly and Kay Hunt collaborated on *Women and Work: A Document on the Division of Labour in Industry 1973–75* 1973–75, in which the artists examined the status of women in industry and the differences between men's and women's pay by conducting a study of a metal box factory in Bermondsey, London – an investigation prompted by the 1970 Equal Pay Act. The work involved film, sound, photography and documentary techniques, in a way that placed less emphasis on individual authorship and the formal and aesthetic characteristics of the work and instead focused attention on the subject matter. The materials drawn from the study were presented in a manner that emphasised their status as incontrovertible sociological evidence of inequality and discrimination. The piece demonstrates how, within the framework of feminism, the document and the structure of the archive were embraced by artists for their apparent authority. The work privileges factual data and the direct testimonies of the workers themselves. Similar social and gender concerns arise in the Berwick Street Film Collective's film *Nightcleaners* 1975, which questioned the conventions of political filmmaking.

Vanley Burke is one of a generation of black photographers who have sought to depict black British identity, including Charlie Philips, Armet Francis, Neil Kenlock and also the filmmaker and photographer Horace Ové. Burke has spent four decades photographing the black community of Birmingham's Handsworth district. His work constitutes a sustained project to record the history and diversity of his community. Stuart Hall has stressed the significance of Burke's photographs in representing 'the first time that an intimate, insider's "portrait" – as opposed to a sociological study – of a settled Black British "colony" and its way of life had found its way into print in the form of a memorable set of images'.[25] Yet Hall also points out that it is not merely the process of 'making visible' that makes the photographs important; he asserts that 'the rich tonal contrasts of Vanley Burke's images, using the lower, deeper, ends of the range, and the printing which "highlines" (i.e. deepens) the near blacks ... cannot be divorced from the explorations of "blackness", of varieties of blackness, and ways of being "black" in Britain, which is at the centre of Vanley Burke's photographic project: form and meaning, together.'[26]

Vanley Burke *The Boy with the Flag* c.1970–79

Tanya Barson

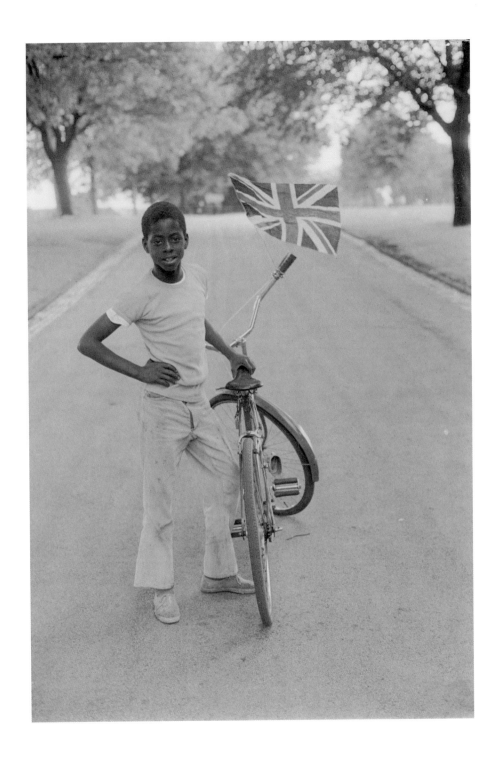

During the 1970s and 1980s black filmmakers experimented with narrative and technique. The Trinidadian-born Horace Ové directed the first feature-length black British film, *Pressure* 1975, which addresses the creation of a specifically British black identity. Filmed in a gritty, realist style, with the exception of one key 'dream' sequence that draws on Surrealist film, it depicts the efforts of a British-born black teenager to find his first job. John Akomfrah and Isaac Julien both made experimental films that challenged the boundaries of art and documentary and their respective conventions. Akomfrah's *Handsworth Songs* 1986 – made under the aegis of the Black Audio Film Collective – is about race relations in Birmingham; it was filmed after local riots and incorporated archival footage drawn from Philip Donnellan's documentary *The Colony* 1964. Julien's *Territories* 1984 – a Sankofa production – is a Vertovian film about the Notting Hill Carnival which tackles the relationship between black British youth and white authority through a montage incorporating news and surveillance footage.

Michael Bracewell has detected the 'quality of Mass Observation within the art of Gilbert and George' through its concern with 'ordinary lives in ordinary streets'.[27] In *Cunt Scum* 1977, one of a series of Dirty Words pictures made in the Jubilee year, obscene graffiti is combined with 'documentary'-style images showing the cityscape, black youths and policemen, evoking racial tensions, street violence and mounting unease within British society at the time.[28] Images included in the work suggest urban alienation and more general issues of surveillance within the city. They hark back to a Surrealist ethnography of the metropolis and yet also parallel documentary forms, used to expose the political reality of Britain in the 1970s.

The artist as historiographer

Questions about the nature, extent and definition of documentary continue to have relevance today and underpin the work of many contemporary artists. This can be viewed as part of a wider concern with the writing of history, concepts of the 'real', memory and evidence, and forms such as archives, diaries and family albums.

Gilbert and George
Cunt Scum 1977

Tanya Barson

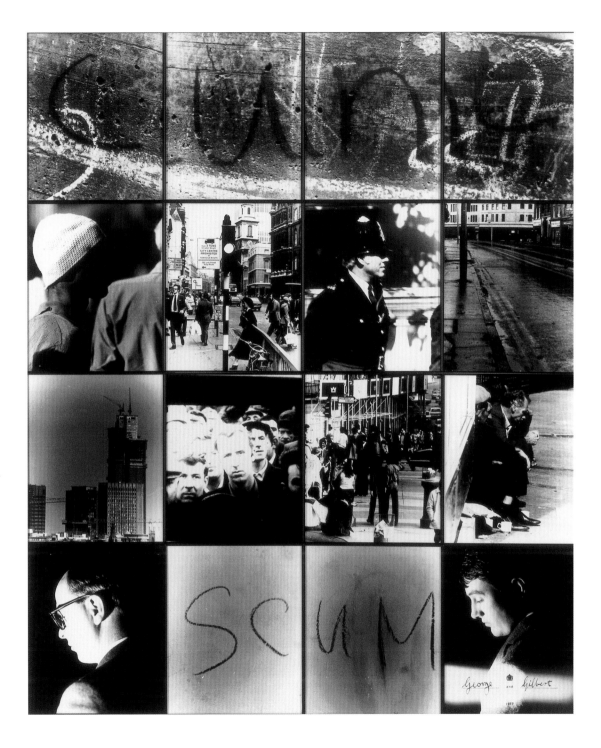

The proliferation of works that undermine the status of the document, including those featuring (false) archives or that restage history, reflect the increasing distrust of fixed concepts of 'fact' and 'history'. Many contemporary artists confront these categories in their work, emphasising ambiguity and questioning definitions of truth and reality. Similarly, media representation and surveillance have also become critical concerns.

Gillian Wearing's first major series of photographs *Signs that Say What You Want Them To Say and Not Signs that Say What Someone Else Wants You To Say* 1992–97 addresses the tradition of documentary photography, but undermines the objective distance of documentary by making explicit the subject's participation, and thus his or her complicity in the creation of the image. Wearing asked passers-by to write down what they were thinking on a sheet of paper which they held up to be photographed. The photographs were intended to be spontaneous; Wearing took pains not to stand in the same place for long so that no-one realised the nature of her project and returned with a considered statement. Rather than stressing social 'type', Wearing's photographs emphasise the individualism of her subjects.

The fly-on-the-wall genre had originated in Britain with Paul Watson's influential series *The Family* 1974; this new form, now ubiquitous, began as a radical disruption of convention, confronting questions of voyeurism and exploitation and addressing the limits and ethics of documentary. Wearing has often credited the influence of television documentaries on her work. In 1995 she stated, 'I really enjoyed the 1970s' "fly on the wall" documentaries that were made in Britain. . . Video was still fresh then, and these programmes felt very spontaneous. Now people know the mechanisms.'[29] Employing familiar forms to speak to the viewer about their everyday experience, Wearing adopts the frame of reference of her audience, yet by subverting accepted conventions, she prompts the viewer to question their supposed transparency and neutrality. In *10–16* 1997, Wearing mimics the 'talking heads' format and privileging of personal testimony that characterises the documentary series *7Up* 1963 and its sequels. In the work, adults lip-synch to the words of children aged from ten to sixteen. Through this apparently simple device, Wearing disrupts the indexical status and thus the authority of the filmed image, creating a documentary

Tanya Barson

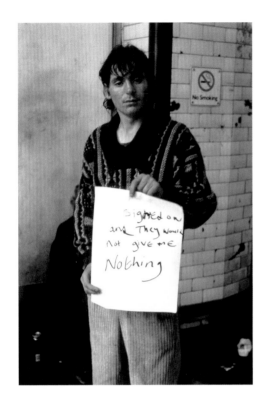

Gillian Wearing *'I signed on
and they would not give me
nothing' 1992–3*

Edith Tudor Hart *Illustration
for the National Unemployed
Workers Movement Agitational
Pamphlet c.1930s*

fiction that reveals the power of the author/artist/editor. *10–16* confronts critical dilemmas raised by documentary: the problem of speaking for others, the complex set of relationships that exist between the filmmaker, their subject and the audience, and the ways in which subjects can be manipulated. Wearing's work highlights how meaning is dependent on the identity and position of the speaker and likewise their observer or audience, and the power relations involved.

Jeremy Deller's *The Battle of Orgreave* 2001 confronts a divisive episode in British social and political history, when miners clashed with police during the 1984–85 miners' strike. The work documents the phenomenon of historical re-enactments, events largely staged by societies composed of amateur enthusiasts, as a manifestation of 'living history' and, as such, part of a tradition of popular interaction and ownership of history. However, Deller involved many of the original participants in the strike, both miners and police, alongside re-enactors, establishing a closer relationship between the event and its re-enactment: 'I thought it would be interesting for re-enactors to work alongside veterans of a recent confrontation, who are an embodiment of the term'.[30] Deller explains that by re-staging the 'battle of Orgreave' he wanted to present it in such a way that it would become 'part of the lineage of decisive battles in English History', thus transforming the way that the event had previously been framed.[31] He conceived it as a form of commemoration, but in its focus on an event that revealed deep fissures in British society it remains a profoundly ambivalent commemoration.

Isaac Julien's video installation *Paradise Omeros* 2002 presents a view of history as dramatised personal memory. Through this personalised account Julien addresses the history of transcultural migration, moving between a colour-saturated, phantasmagorical St Lucia and a brutalist, grainy Britain, drained of colour. Fantasy mingles with painful, sometimes violent recollection. Julien has written

art must, I believe, begin with – or in my case, make a return to – the personal as a symbolic 'archive'. *Paradise Omeros* enacts such a return, as a visual odyssey enriched by semi-autobiographical incidents of childhood and drawing on the knowledge and

experience of the displacement, trauma, and alienation of the diasporic subject. It is a film about the legacies of globalisation, if you like, told in images, stories, and sounds. For global capitalism. . . has meant that my parents emigrated from St. Lucia and came to England, leaving behind their land, their culture, and their language – almost.[32]

Julien's work fuses divergent approaches to history, memory and imagination as well as to filmic construction.

Of documentary value

Documentary continues to be an area in which new forms or structures, such as the fly-on-the-wall approach, are created. In turn these inspire and transform the approaches and visual language employed by artists, who adapt them to their own ends. Such new forms also transform the expectations and role of the audience. Documentary constitutes a key visual paradigm within British culture: it is an established form for artists to respond against but it is also potentially an area of radical innovation. Documentary is far from straightforward or neutral and its influence on visual culture has been complex and multifaceted. It is clear that, from the outset, the documentary field accommodated a variety of different strategies, styles, motivations and products, as well as political views. As Grierson stated in relation to documentary film, it is important to note 'different qualities of observation, different intentions in observation, and, of course, very different powers and ambitions at the stage of organising material'.[33] This exhibition demonstrates that there has been a sustained, though complex and changing, dialogue between art and documentary in Britain – a dialogue that continues today.

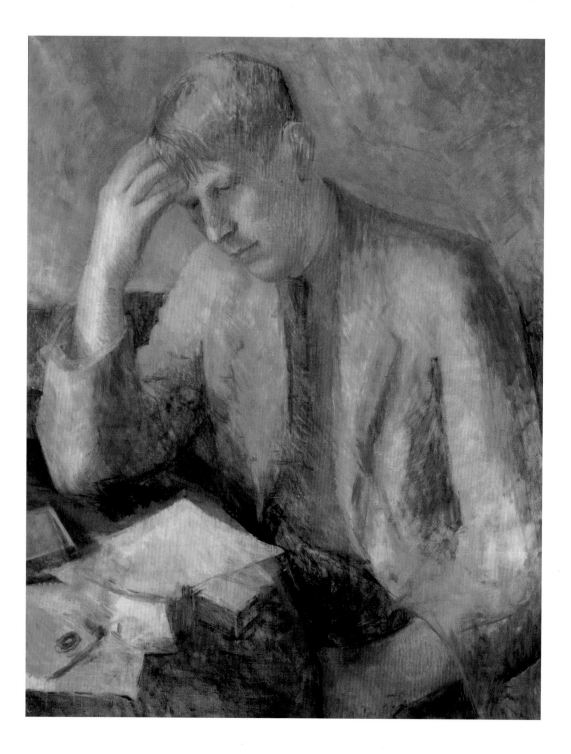

The touch of time

LYNDA MORRIS

In the 1936 poem 'Letter to William Coldstream Esq.', W.H. Auden wrote about their time together in the GPO Film Unit in Soho Square:

> Very well then, let's start with perceiving
> Let me pretend that I'm the impersonal eye of the camera
> Sent out by God to shoot on location
> And we'll look at the rushes together.

Auden encouraged Coldstream to return to painting in 1936 after three years' filmmaking. Coldstream then painted portraits of Auden, Christopher Isherwood and Stephen Spender, each picture the result of many sittings. The film *Cabaret* begins with a quote from Isherwood's 1939 book *Goodbye to Berlin*: 'I am a camera with its shutter open, quite passive, recording, not thinking. . .'.

Isherwood, Auden and Spender all stayed in Germany in the late 1920s and early 1930s and wrote about the decadence of the period. They referred in their books to their own snapshots and there is a sense that the camera was an icon of Weimar Germany:[2] from Agfa to Leica, from John Heartfield's photomontages to August Sander's *People of the Twentieth Century* to the Workers' Photography Movement.[3] The Neue Sachlichkeit painters, Otto Dix and George Grosz, painted cruel images of whores, war-wounded, pimps and capitalists, property developers and arms dealers. Their pictures represented the alienation

William Coldstream
W.H. Auden c.1938

of artists and intellectuals; their lack of compassion contributed to the failure of the Weimar Republic and therefore, albeit unintentionally, to the rise of Fascism.

Coldstream's portraits of the 1930s' poets were less spectacular but a lot more compassionate. Coldstream wrote about his political ideas in *Art in England*:

> The slump had made me aware of social problems, and I became convinced that art ought to be directed to a wider public; whereas all ideas that I had learnt to regard as artistically revolutionary ran in the opposite direction. It seemed to me important that the broken communication between the artist and the public should be built up again and that this most probably implied a movement towards realism. . .[4]

Coldstream influenced his contemporaries, Frank Graham Bell, Victor Pasmore and Claude Rogers. They started a small independent art school in Euston Road. Coldstream used ideas from filmmaking in his portrait-painting. He used monocular vision, closing one eye to represent three dimensions as a flat image; he concentrated on tone rather than colour; and he worked in front of the subject, constantly measuring at arm's length and checking his use of 'sight size'. The measurements marked the passage of time like the blur of movement in a photograph or film. He was limited to subjects that would keep still, painting portraits, still lifes and cityscapes. Anthony Blunt wrote about Coldstream for the *Spectator* magazine: 'In art, as in morals, honesty is often unexciting at first sight. But the test comes not at the first, but at the fiftieth hour; and it is not obvious which will look duller then – a Picasso or a Coldstream.'[5]

Coldstream had studied at the Slade under Henry Tonks in the late 1920s. Tonks was a surprising figure, a Victorian but also a progressive who had worked for Frederick Treves, doctor to Joseph Merrick (the 'Elephant Man'), in Whitechapel. He encouraged Jewish charities to fund students at the Slade, including Mark Gertler, Jacob Kramer, Thomas Lowinsky, Bernard Meninsky, David Bomberg and Claude Rogers. Helen Lessore remembered that Tonks' favourite quotation was from Goethe: 'All eras in a state of decline and dissolution are subjective; on the other hand all progressive eras have an

William Coldstream
Rifleman Mangal Singh: 2/6
Rajput Rifles 1943–4

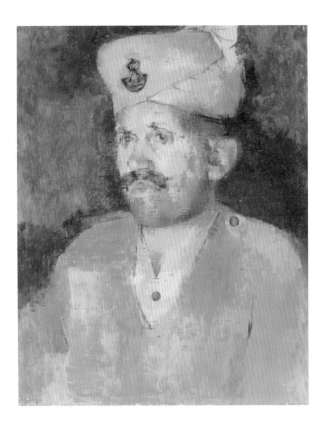

objective tendency'.[6] This is a formula that recurs in Marxist social histories of art.

Tonks advised Coldstream to attend lectures by Richard Walter Sickert. Around 1930 Sickert was making paintings from drawings and photographs by other people. The drawings were from the *Graphic Magazine* of the 1870s – his *Echoes*. At the same time he made paintings based on newspaper photographs. The contrast expressed the change that had taken place over the previous fifty years in the popular idea of reality, from 'Quality Street' to daily press photographs. Coldstream's portraits differ from Sickert's because they are about the consistency of the popular idea of reality over the previous century. That consistency is a result of the constant comparison of realism in painting to real people in a photograph. The idea of what is an acceptable representation of the real has changed very little since the invention of photography in the 1840s.

So Coldstream looking back to Degas, and his use of ideas from photography, made sense.

Coldstream was introduced to John Grierson at the GPO Film Unit by Paul Rotha, who was a contemporary at the Slade. Rotha's films *The World is Rich*, *Land of Promise* and *World of Plenty* give an internationalist view of famine and hunger, which had been a shameful factor for the British Empire not only in Ireland but also in India and China in the second half of the nineteenth century.[7] Coldstream's grandfather spent most of his life in the Punjab in the Indian Civil Service. It was only the working class who remained untainted by the exploitation of Empire. Coldstream was involved in an exacting, and sometimes withering, honesty in life as well as in perception.

In 1936 Coldstream met the anthropologist Tom Harrisson, who returned from field research in the New Hebrides and set up Mass-Observation with Charles Madge and Humphrey Jennings. Harrisson thought that the lives of the working class in Northern England were a worthy subject for an anthropological field study. He made an early identification in anthropology between race and class.[8] He persuaded Coldstream, Graham Bell, Humphrey Spender and Julian Trevelyan to go to Bolton as part of the 1937 *Worktown* study. Coldstream and Graham Bell painted two cityscapes from the rooftop of the museum.

Graham Bell made one overtly political painting, *Red White and Blue c.*1938, showing a mounted policeman threatening a woman protester. The painting was lost in the Blitz. Coldstream never made political paintings but he was a member of the Artists' International Association and he met Communist Party members such as Clive Branson regularly for dinner. Branson was interned and radicalised by the Spanish Civil War. Where Trevelyan and L.S. Lowry adopted childish mannerisms to represent working-class subjects, Branson used the style of untrained working-men artists. The Ashington Group from Northumberland painted their lives as pitmen in the 1930s and showed them in London. Henry Moore remembered their vision when he started his coalface drawings in the 1940s.

Branson came from a wealthy family and he bought Marx House on Clerkenwell Green for the Communist Party. John Viscount Hastings worked with Diego Rivera on the School of Dentistry murals

Lynda Morris

in Chicago, and painted a mural of the heroic worker for Marx House. Richard Carline, the brother-in-law of Stanley Spencer, knew Philip Evergood from the Slade and he arranged for Carline to show in the WPA Gallery in New York in 1938. Carline, Mischa Black, Anthony Blunt and Francis Klingender started to plan a European exhibition of the Mexican Muralists. The Mexican exhibition fell through and they went on to organise a WPA exhibition with Stuart Davies and Harry Gottlieb for the Whitechapel in November 1939, but war broke out. They tried to revive the plan in 1946 but the times had changed.[9]

The Artists' International Association was originally the Artists' International, inspired by Cliff Rowe's visit to the USSR.[10] Through the AIA Marxist ideas became influential amongst artists from 1933 onwards. The 'Three James', Fitton, Boswell and Holland, illustrated *Left Review*; Peter Peri developed murals in concrete for workers' estates and schools; Patrick Carpenter was a theorist and a Metaphysical Realist; Percy Horton painted the unemployed in his Workers' Education Authority evening classes; and Carel Weight developed

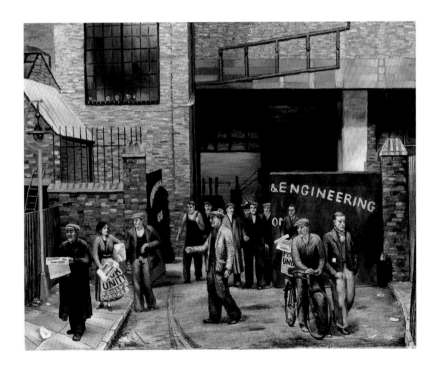

Clive Branson *Selling the 'Daily Worker' outside Projectile Engineering Works* 1937

an endearing English Realism. The AIA developed a Popular Front Against Fascism and founded the Artists' Refugee Committee. Their mixed touring exhibition became the model for the Council for the Encouragement of Music and the Arts (CEMA), which led in turn to the Arts Council of Great Britain. (It always amuses me that the founding of the Arts Council was announced in Parliament in 1944 by Winston Churchill.)

There has been no adequate tribute to the influence of this generation of refugees and the knowledge and scholarship they brought to Britain from the continent of Europe. The development

Graham Bell *Thomasen Park, Bolton* 1938

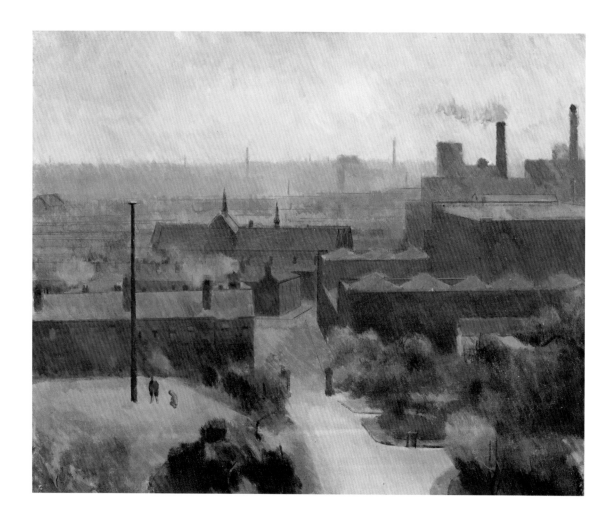

Humphrey Spender
Panorama – Central Bolton from Mere Hall Art Gallery c.1937–8

William Coldstream
Bolton 1938

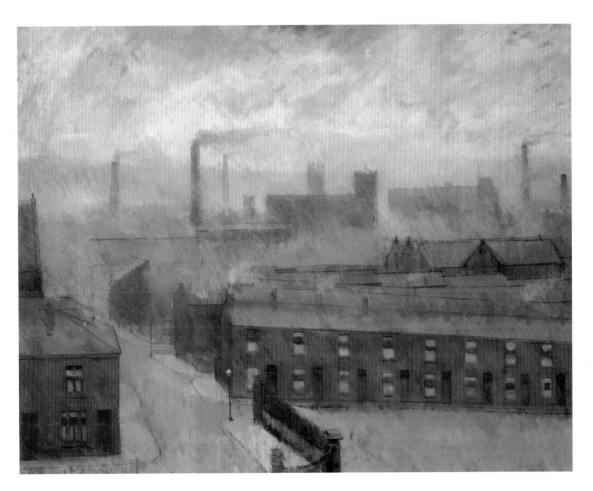

of a social history of art encouraged realism amongst British artists. An influence on Francis Klingender and Anthony Blunt was the Hungarian art historian Frederick Antal. He arrived in London from Berlin in 1933, after visiting Moscow in 1932. He was Head of the Directorate of Arts and Museums during the Béla Kun Revolution in Hungary in 1919. He lectured at the Free School of Humanities, known as the Sunday Club, started in 1915 by Lukács, with Charles de Tolnei, Béla Balázs, Karl Mannheim and Arnold Hauser. Antal studied art history in Vienna with Alois Riegl and Max Dvořák and in Italy and Paris. From 1926 to 1931 he was an editor of *Kritische Berichte* and was in contact with the Bauhaus and the Frankfurt Institut für Sozialforschung. Antal introduced into Britain the social history of art as a means of understanding the spirit of the age and historical consciousness (*Geistesgeschichte*).

Antal's book *Florentine Painting and its Social Background*[11] looked at the gap of a hundred years between Giotto and the beginnings of the Italian Renaissance. He traced the reason for the gap to the power of patronage falling into the hands of less progressive forces in Florence, who patronised decorative artists because their interests were in property rather than the realist artists who represented the forces for social progress. Antal's influence led Klingender to work on then forgotten areas of art history which had a contemporary relevance; he published *Hogarth and English Caricature*, *Goya in the Democratic Tradition* (begun during the Spanish Civil War) and *Art and the Industrial Revolution*.

In 1943 Klingender published *Marxism and Modern Art*.[12] In this book he writes about the Soviet Union as a feudal, agricultural society struggling to develop modern industries, a context in which the iconography of the heroic worker fitted national aspirations. In the industrialised countries of Western Europe and the USA there were no heroic workers; there were only the miserable figures of the Depression: the unemployed, the hunger marchers and the dustbowl sharecroppers.

In his reviews for the *Spectator* Anthony Blunt developed the idea of the 'New Realism' as part of modernism. In 1937 he wrote about an exhibition of Moholy-Nagy's work at the London Gallery, concentrating on the artist's work with lights for the cinema: 'New technical processes and methods of presentation enable the photographer to discover

and convey new facts, and to convey them with new intensity. . . discoveries such as Moholy Nagy's are aids to the New Realism.'[13]

Moholy-Nagy came to London in 1935 with help from Antal. In 1982 his widow still lived in Eton Avenue, NW3, with the furniture made by Marcel Brauer when he arrived in London. Antal was a friend of Walter Gropius. He knew Matisse and Le Corbusier and he owned a drawing by Picasso, with whom he maintained some contact. He had a very high opinion of French Impressionism, and it is clear from his writings about Joseph Highmore[14] that he approved of Coldstream's naturalism. Antal associated realism in painting with the revolutionary moments of a progressive bourgeoisie as represented by Chardin or Vermeer. Coldstream wrote for the *Listener* about Holbein and Courbet.[15]

Antal helped his fellow art historians Johannes Wilde, Charles de Tolnoi and Arnold Hauser, as well as Vincent Korda, Paul Veshev and Ralf Brandt, to settle in London. After 1945 Antal taught at the Chelsea School of Art and his students included John Berger. Berger would visit him at his home in the evenings with Paul Hogarth. Antal's wife Evelyn said: 'Antal was conscious that it was difficult to be on the Left and to be foreign in England, during the Cold War. His scholarship protected him but he was also careful not to be actively involved in politics.'[16]

Coldstream's initial reaction to the outbreak of war in 1939 was as a pacifist. In his *Journals* William Townsend[17] describes Coldstream's struggle with his conscience. This was an important subject for Townsend, who was a Quaker. His brother, Peter Townsend, later editor of *Studio International* and *Art Monthly*, was sent to China in 1940 with the Friends' Ambulance Unit. The proposal that Coldstream be appointed an Official War Artist, through the influence of Kenneth Clark, solved Coldstream's dilemma. The most important of his war paintings are the series of portraits of servicemen from India and Jamaica. Coldstream was possibly thinking about Harrisson's social anthropology and the equation of race with class. His decision to spend time during the war in the company of servicemen from India and Jamaica and concentrate on painting their portraits may also have been influenced by his family history.

Victor Pasmore increasingly moved towards abstraction as a painter after 1944. As the war ended Coldstream looked outside

England and became interested in the work of Alberto Giacometti. David Sylvester has acknowledged that Coldstream was instrumental in bringing the Giacometti exhibition to the Tate Gallery,[18] which led to the gift of his work to the museum. Giacometti explained the importance of cinema to his conception of sight and of reality:

> The true revelation, the great shock that destroyed my whole conception of space and finally put me on the track I'm on today came in 1945, in the newsreel theatre *Actualités Montparnasse*. . . I went in, saw the film, left the theatre, I was in the street again, in a café – it wasn't anything special, nothing really happened at all. . . Until the day they separated; instead of seeing the person on the screen, I saw – influenced by the drawings I was doing at the time – unfocused black spots that moved. I looked at my neighbours – and suddenly I saw them as I had never seen them before. Everything was different, the spatial depth and the things, and the colours and the silence. . . It was, if you will, a sort of perpetual enchantment of every-thing. . . From that day on, because I had realised the difference between my way of seeing in the street and the way photography and films see things, I wanted to represent what I saw.[19]

Coldstream was Chairman of the Arts Council of Great Britain and the British Film Institute. In 1960 he started a film department at the Slade and appointed Thoreau Dickinson to run it, whose films included *Gaslight* 1940, *The Next of Kin* 1942 and *Secret People* 1952. Dickinson was an expert on early Russian cinema who had been involved in documentary film in the 1930s and had worked in Israel and for the United Nations. The theorists Charles Barr and David Curtis, the artist Gustav Metzger, the filmmakers Lutz Becher and Derek Jarman, and the writer David Lodge all attended Dickinson's screenings. His evening screening also had an impact on painters: Colin Self, Len McComb, Terry Atkinson, John Wonnacott, Stephen McKenna and Marc Chaimowicz all spoke about the importance to their work of the rare early films Dickinson had flown in from the USSR and Central Europe. The film programme paralleled concerns with film and popular culture in the paintings, and in the teaching, of Michael Andrews and Larry Rivers at the Slade.

Lynda Morris

In 1985 I worked with Coldstream on an interview about Tonks' teaching and I asked him why the Slade kept its life rooms when the effect of the *Coldstream Report on Art Education* that he had chaired in the late 1950s had been to shut down life rooms in art schools across the country. My memory of the conversation is that he said:

> You should remember that I was only the chairman of the Coldstream Report. While the committee was sitting Victor Pasmore organised *The Developing Process* exhibition at the ICA in 1959. He was very successful with the Bauhaus idea and there was little I could do against the tide of opinion. You should go and read the Coldstream Committee papers in the National Archives in Kew for the full account of our arguments.

Finally he added, 'It should have been called the Pasmore Report, then people would have understood what was happening.'

It would appear that Coldstream developed a film school at the Slade in 1960 as a critique of the argument he had lost with the *Coldstream Report*. This would suggest that Coldstream's model of an art education was figurative painting and drawing linked through perception to photography and film. If Coldstream's model had been successful, most people working in film and television in this country over the last 40 years would have been educated in the art schools. As it is, it has taken 45 years, and the development of digital technology, for art schools to develop a combination of Pasmore's and Coldstream's polarities.

Some painters have made their own combination out of the polarisation of abstraction and design and documentary realism. I would suggest that the blur in Richard Hamilton's *Kent State* 1970 of the television news picture of a student shot dead by the National Guard during an anti-Vietnam demonstration is one example. Given Gerhard Richter's belief that 'Hamilton and I have worked for many years in parallel',[20] the *18. Oktober 1977* series painted in 1988 of the CCTV footage of the Red Army Faction bodies in Stammheim Prison are the continuation of this documentary tradition in painting. By painting these fleeting moment of TV film, the painters ensured that we will not forget, even that we may eventually be overwhelmed by the evidence against 'the impersonal eye of the camera'.

Patrick Keiller

London 1993

Un-making history: thoughts on the re-turn to documentary

MARK NASH

Making History charts the history of documentary practice in British art, photography and cinema. It chronicles the history of a form and insists on the important role of artists in the development of that form, as well as demonstrating a productive fluidity in the concept itself. I would like to explore further some of the points raised in Tanya Barson's keynote essay. While I would agree that documentary, loosely understood, has constituted a 'key visual paradigm within British culture, both an established form for artists to respond against but also potentially an area of radical innovation', I am not sure whether that argument continues to have the same force today.

The following remarks chart something of the historical development of the form, with some indications of aesthetic and political issues at stake in different periods. The British documentary movement in the 1930s was composed of three kinds of filmmaking institutions:[1] official public sector film units such as the Empire Marketing Board and National Coal Board Film Unit, corporate film units such as the Shell Film Unit, and independent units such as Kino, the Film and Photo League and the Progressive Film Institute, associated with the British Communist Party.[2] These latter were to document the labour movements, struggles against fascism, demonstrations against poverty, strikes and so on. Class is indeed a key concept for understanding British documentary. Those making the films and, after

the Second World War, television programmes tended to be white, male and middle class, until the development of the National Film School from 1971 began in a small way to encourage film-makers from more diverse backgrounds.

John Grierson's early films for the Empire Marketing Board (which subsequently became the GPO Film Unit) were indebted to the Soviet development both of a documentary cinema and of a fiction cinema rooted in recent historical events. (*Drifters* 1929 screened with Sergei Eisenstein's *Battleship Potemkin* 1925 at the London Film Society in 1929.) The 1917 Russian Revolution and the massive shift that country was undergoing from feudalism to industrial socialism inspired British artists, writers and working men and women. As is often noted, Grierson was concerned to educate the public in the political and social complexities of contemporary society, with an emphasis on education rather than entertainment. In this Grierson was following the example set by fellow Scotsman John Reith, first general manager of the BBC in 1922, and director-general from 1927.

Alberto Cavalcanti
Coalface 1935

Mark Nash

Drifters and *Granton Trawler* 1934, as well Basil Wright and Alberto
Cavalcanti's *Coalface* 1935, present the conditions of work in ways that
are defining even to the present day.[3] Watching Steve McQueen's
video installation *Western Deep* 2002, for example, one is immediately
taken back to 1930s' films on coal mining such as *Coalface*. Indeed
part of the point of McQueen's piece is surely that those conditions of
work have not changed greatly (at least as far as mines in developing
countries are concerned). What these 1930s films did not do, however,
in contrast to their Soviet counterparts, was to provide an under-
standing of the part the labour process played in the capitalist
system of production.

The Second World War produced one of the most celebrated films
of the movement, Humphrey Jennings' *Listen to Britain* 1940. In *Listen
to Britain*, inspired by the methods of Surrealist montage, Jennings
creates an assemblage of sounds and images of everyday life in
wartime: the factory floor and the dance-hall, the Old Bailey as an
ambulance station, tanks in a medieval village. It was an inspired
piece of propaganda, aimed in part at eliciting support from the

United States. The tone is almost nostalgic – this is the country as you will never see it again (unless you support the UK war effort). In its use of the emotional power of montage it is clearly indebted to Soviet cinema, as well as to a decade of experiments in Surrealist art, photography and film, which in their emphasis on the power of the unconscious were directed against the use of a controlling narration. Each viewer has the experience of discovering the film for themselves and forging a personal identification with the image of Britain at war. What is less commented on in Jennings' film is the absence of representations of the empire and the colonies, as if – unconsciously, under the pressures of war – Britain has already given up its imperial ambitions.

There was little direct criticism of Britain's colonial empire prior to the Second World War, in part no doubt because the labour movement was more focused on struggles at home and the international dimension of the movement was focused on the Socialist International. Grierson's Empire Marketing Board, bizarrely as it might now seem, was initially concerned with editing Soviet documentaries (such as Victor Turin's documentary of the building of the Turkestan–Siberian Railway , *Turksib* 1929) for UK distribution, and attempting to introduce the language of Soviet documentaries into the British productions.

Song of Ceylon 1934 was produced by the Empire Marketing Board's successor body, the GPO Film Unit, together with the Empire Tea Marketing Board and the Ceylon Tea Board. It is however very much more than the sponsored documentary this would suggest: it is rather a celebration of colonial modernity, of the benefits trade and enterprise were bringing to the country that was to become Sri Lanka. Its experimental soundtrack echoes the symphonic structure of Vertov's hymn to Soviet industrialisation, *Enthusiasm* 1932. In *Song of Ceylon* quasi-anthropological narration is montaged with constructed 'exotic' and 'industrial' sounds. Lyrical camerawork confirms the message of a beneficent colonialism.

The history of documentary cinema in the British Empire is rarely connected to that of the UK proper, although some of the key players, such as John Grierson, were involved in both areas. In 1935 British colonial authorities experimented with establishing documentary film production in Tanzania (then Tanganyika), using local people to

Amber *Launch* 1973

produce educational films on local issues, very much in the spirit of Grierson and Reith. With the outbreak of war a Colonial Film Unit was established with branches in East, Central and West Africa to make war propaganda for an African audience, and after the war (on Grierson's recommendation) a film school was established in Accra, Ghana (the then Gold Coast). British television covered the independence struggles and celebrations of Britain's former colonies in the 1950s and 1960s, but subsequent documentary film-making has been much less engaged in the post-colonial space of the British Commonwealth.

Free Cinema was a loosely knit group of film-makers (including one woman, Italian Lorenza Mazzetti) centred around Lindsay Anderson, whose films and plays were heavily influenced by the ideas of Bertolt

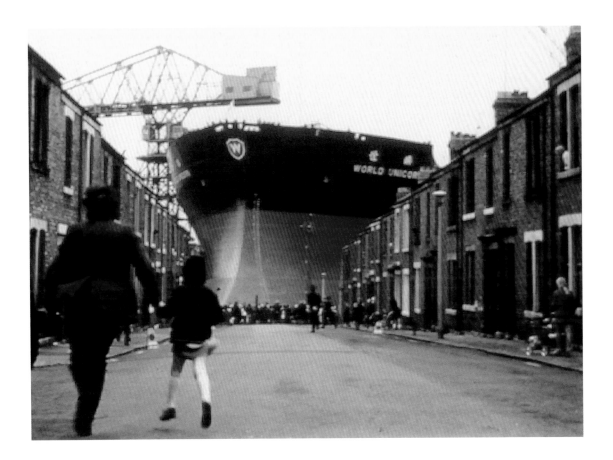

Brecht. A precursor of 'independent' cinema, the films were 'free' in the sense that they were personal statements made outside the framework of the film industry. Karel Reisz's *We Are the Lambeth Boys* 1959 has much in common with Lindsay Anderson's *Every Day Except Christmas* 1957. These were some of the first projects to be funded by the British Film Institute's Experimental Film Fund, and featured ordinary, mostly working-class people both at play (Lambeth teddy boys) and at work (the Covent Garden market). These are films very much in the tradition of Humphrey Jennings, but they still retain something of Griersonian paternalism in their address and use of voice-over. This may be partially due to Anderson's confusion of his very middle-class anti-establishment anger (John Osborne was another such) with class struggle. Indeed one could argue that the intellectual weakness of British cinema prevented it from benefiting from the experiments of *cinéma vérité* in France, as in Jean Rouch and radical socialist Edgar Morin's exploration of everyday Parisian life in *Chronique d'Un Été* 1961.

The documentary movement that Grierson helped establish was in the liberal and Fabian tradition, sympathetic to working-class people but nevertheless incorporating something of an establishment point of view, and one can sense that connection in the Free Cinema group. Yet from its inception this history has also been the subject of contestation in more militant film-making, both in the 1930s and in the subsequent work of British documentary groups in the 1970s and 1980s.

Amber, Cinema Action and the Berwick Street Film Collective were groups that began work in the 1970s. Both Amber and Cinema Action were concerned with the empowerment of their working-class subjects. Amber perhaps was the more Griersonian, being concerned with the documentation of working-class life, whereas Cinema Action was concerned with supporting and publicising political struggles, whether in the factory or against the occupation in Northern Ireland. Berwick Street was the most engaged with the debates on the role avant-garde cinema could play in producing a political cinema – ideas associated with Jean-Luc Godard and Chris Marker in France and publicised in the UK by *Screen* magazine amongst others.

Berwick Street's *Nightcleaners* 1975 is a film that has aged extremely well. Its exploration of a durational aesthetic recalls of course the

Karel Reisz *We Are the Lambeth Boys* 1959

Mark Nash

experiments of Warhol and others, but within a framework provided by both experimental cinema and conceptual art (Mary Kelly, who was working on her 'Women and Work' project at the time, was part of the group). This film documents a struggle for a living wage by marginalised women and migrant workers, a subject that is as topical today as when the film was made in 1975. The repetitive nature of the work is reflected in the form and experience of watching the film itself. The audience is drawn into the world of its subjects, as well as being presented not with a representation of reality but (in Godard's phrase) with a reality of representation.

In the 1970s, feminists challenged the male dominance of the industry and some women were able to direct, produce, shoot and edit films in more visible[4] forms than hitherto. The London Women's Film Group supported the work of a number of female directors, producers and camera operators. The pre-war documentary movement

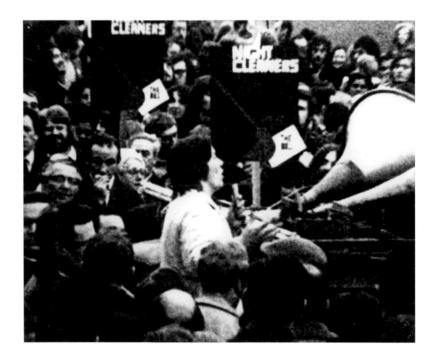

Berwick Street Film Collective
Nightcleaners 1975

had seriously neglected women's contribution to social struggles. Esther Ronay's *Women of the Rhondda* 1972 documented women's contribution to the Welsh miners' strikes of the 1920s and 1930s.

Isaac Julien
Territories 1984

Similarly, in the 1980s, under the aegis of Channel 4 television and the film trade union ACTT, a series of film workshops began to give expression to black and Asian voices. Work from two of these groups is included in the exhibition. *Handsworth Songs* 1986, directed by John Akomfrah from the Black Audio Collective, mined the archive of representations of black people in British film and television to provide a historical perspective for the race riots in Birmingham at that time. *Territories* 1984, directed by Isaac Julien and produced by the Sankofa Film and Video Collective, explored the racial tensions in the Notting Hill carnival through a meditation on the exclusion of black Britons from concepts of national identity, an exclusion paralleled by the homophobia of 1980s' hetero-normative England. Both films develop the poetic vocabulary of British documentary, using montage, archive film and voice-over to lyrical but incisive effect.

Patrick Keiller's *London* 1994 explores a very different London to that of Isaac Julien. It is a London as uninhabited as Paris in Eugene Atget's photographs. A narrative voice-over from an imaginary protagonist, Robinson, steeped in eighteenth- and nineteenth-century French and English writers, effects a disjuncture between sound and image paralleling that created by the use of a 1680 commentary by Robert Knox in *Song of Ceylon*. Keiller's text effects a retrospective reading – nostalgically tracing the past in the present

Mark Nash

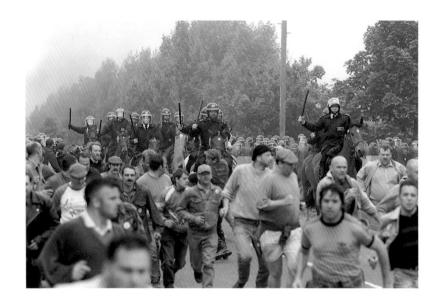

images of London. Wright's use of an explorer's text against documentary footage shot in Ceylon elides the discovery, colonisation and modernisation of Ceylon into a single movement. Keiller's formal framing parallels the photographic genre of the Düsseldorf school (Bechers et al.), and by undercutting the stereotypical representation of familiar London landmarks serves to question the nationalist allegories they are traditionally part of. His difficulty in imagining a future contrasts with other representations of London, such Phil Mulloy's *A History and the City* 1977 and Black Audio's tape slide *Sounds of Empire* 1991 or *Twilight City* 1987, which interrupt images of the city with narratives from Ireland and the former colonies respectively.

By the 1980s documentary had become both a means of allowing new voices and new representations of Britain and Britons onto the screen, and a form for controlling those voices. Television commissioning editors felt that documentary was the appropriate form for young black film-makers and collectives. They would naturally want to make films about their communities and not get involved in the terrain of high culture. Some of the early fictional experiments, such as Isaac Julien's *Looking for Langston* 1989, were commissioned as documentaries but managed to evade the commissioning restrictions.

Basil Wright
Song of Ceylon 1935

That film was a complex meditation on the constitution of black identity explored by paralleling the life of Harlem Renaissance poet Langston Hughes with the lives of contemporary black and gay Londoners. *Paradise Omeros* 2002, inspired by Derek Walcott's poem *Omeros*, explores another set of threads which make up black British identity by presenting a story of a young West Indian, who is also Homer's and Walcott's Achilles, eternally migrating between the present of St Lucia and London, and the past of Greek myth and the triangular trade.[5]

As the exhibition *Making History* makes very clear, many artists moved between media, from painting or photography to film or vice versa. The Euston Road school of William Coldstream et al. moved between painting and documentary film. The Surrealist experiments of 1940s' photography clearly influenced, say, Robert Hamer's *It Always Rains on Sunday* 1948, with photographer Douglas Slocombe adopting a *film noir* vocabulary for this study of repressed working-class passion.[6] Hamer indeed points to an alternative history for post-war cinema, not that of the documentary-influenced 'kitchen

Mark Nash

sink' realism but the Symbolist and Expressionist cinema of Powell and Pressburger, Hammer horror, the later Lindsay Anderson and indeed Derek Jarman.

Today the move towards so-called 'reality television' and the quasi-abandonment of notions of quality in British television, together with the proliferation of cable and now digital channels, have resulted in a fragmentation of the audience. Contemporary moving-image artists reflect this fragmentation in their works. In his re-enactment projects such as *The Battle of Orgreave* 2001, for example, Jeremy Deller is both preserving the memory of political struggles which no longer have a force in the culture, and indicating how contemporary sensibilities have become detached from those histories that have formed it. A similar movement can be detected in Gillian Wearing's *Drunk* 1999. It invokes a history of observational documentary representations of working people's lives, while undercutting them with its confrontational presentational aesthetic. It forces us to question our relationship to people who have been relegated to the margins of society. It also implies an abandonment of any narratives of social improvement or inclusion.

The proliferation of documentary forms in contemporary art is both an indication of the productivity of the form and a symptom of an underlying failure. The very form which developed to enable us to think about history and social change has almost turned into its opposite – we are now in a mode of iteration, an accumulation of information that can render us informed but paradoxically unable to act. Nevertheless the fluidity with which artists are able to move between media and forms, including documentary (for instance between photography and video, between fiction and documentary), and their willingness to incorporate documentary strategies of contemporary art, can only be a good sign. When Langlands and Bell, for example, were commissioned to visit Afghanistan as war artists, the social and political reality they observed transformed their practice, producing an important series of works, *The House of Osama Bin Laden* 2003, shortlisted for the Turner Prize. The realities of our contemporary world continue to make documentary modes of apprehension urgent and pertinent.

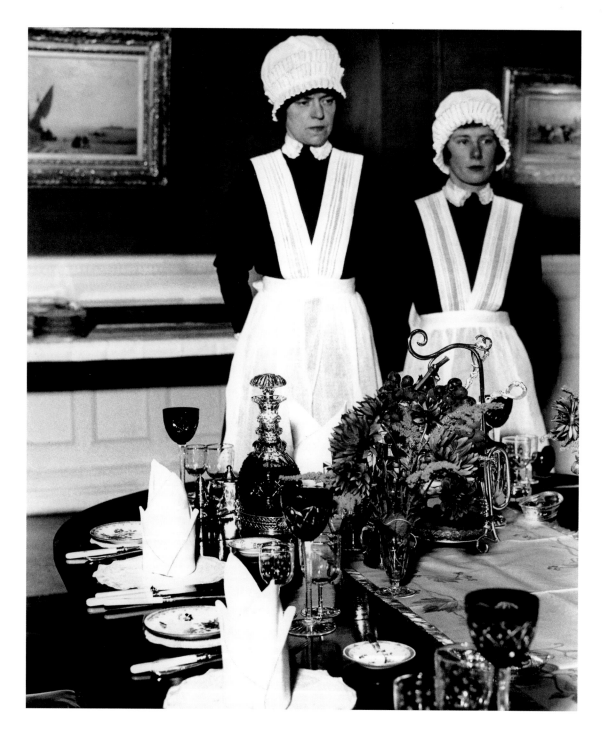

The career of a photographer, the career of a photograph: Bill Brandt's art of the document

DAVID CAMPANY

Photographs are highly mobile images. Made at particular times, often for particular reasons, they can reappear in other circumstances. Some of the best known photos have had long lives and numerous manifestations – in magazines and books, on gallery walls, postcards and posters. Many are essentially simple, their meaning able to withstand the vagaries of cultural transit. Others are more pliable, yielding to different demands, shifting in meaning, lending themselves to different ends. Some become well known through a single, highly visible use (on television or on the cover of a newspaper). Others accrue their meaning over time.

One of the best known and most reproduced British images has had one of the longest and most intriguing careers of any photograph. Bill Brandt's *Parlourmaid and Under-parlourmaid Ready to Serve Dinner*, as it has come to be known, was taken in 1933. Today it has several roles. At times it is used to stand in for all of Brandt's work. It is regarded as a milestone in documentary photography *and* a milestone in art photography. And it is seen as an illustration of life in the 1930s.

Its inaugural appearance was in Brandt's first book *The English At Home* (1936). This little hardback contained a series of 63 photographs in which the photographer traversed the country to make a pictorial

Bill Brandt *Parlourmaid and Under-parlourmaid Ready to Serve Dinner* 1933

survey of sorts, moving across the social classes. He titled the image *Dinner is Served* and it appeared opposite an exterior shot titled *Regency Homes in Mayfair*. The two photographs are similar in form with their cluttered foregrounds, flattened vertical backgrounds and bold interplay of black and white shapes. Through this we might assume that the maids worked in such a Mayfair home, perhaps even one of the homes we can see. With its interest in the disparities between the wealthy and the working class, *Dinner is Served* is in keeping with the overall theme of *The English At Home*. The book's front cover showed a posh crowd watching the races at Ascot in their fine clothes while the back showed a miner's wife and children in their cramped living quarters. Inside, a shot of a playground in London's working-class East End sits opposite one of an upper-middle-class children's party in Kensington, west London. A workmen's restaurant contrasts with a 'Clubmen's Sanctuary'.[1] However, *Dinner is Served* is unusual in that something of those tensions is at play *within* its frame. We see a dressed dinner table of the well-to-do and the attending women. The head parlourmaid seems at first glance to express a stern resentment mixed with weariness and professional discipline, but there is a kind of blankness about her too. Her junior has the vacant expression of an adolescent, not yet able to grasp the social forces that will shape her, perhaps. The reading of the image by the photographer Nigel Henderson is similar but more pointed: 'In [Brandt's] marvellous photograph the two house parlourmaids, prepared to wait at table, have eyes loaded like blunderbusses. Their starched caps and cuffs, their poker backs, mirror the terrible rectitude of learned attitudes. They have the same irritated loathing in defence of caste that shows in portraits of Evelyn Waugh.'[2] Rhetorically, this is an image of pairings. Its economy of form and content forces us to see in opposites, tapping into and reinforcing a general understanding of the social structures of class and service. It is as barbed as *The English At Home* gets. There is nothing overtly angry or revolutionary in the generally restrained tone of Brandt's book. However, it was unusual in bringing different classes into one volume, leaving the viewer to reconcile the social contradictions and inequities. As the historian John Taylor put it, the book's audience was 'expected to see the relationships and differences that built up page after page'.[3] With its disconcerting, uneasy mood

David Campany

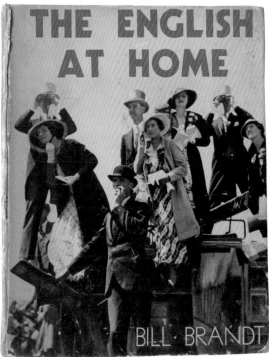

across the social sweep *The English At Home* demanded a lot from its audience. But the English were not ready for such a book. It made little impact and it all but vanished. However, looking back in 1978, Brandt wrote to his publisher Sir Brian Batsford: 'At the time before the war you were the only publisher who was interested in my photographs. It may amuse you to hear that I saw the other day an advertisement in an American magazine in which they offered a second-hand (damaged) edition for $500. In 1936 you sold the book for five shillings and as you may remember after some years it had to be remaindered.'[4]

In his introduction to *The English At Home* the critic Raymond Mortimer wrote of the photographer's fascination tempered by reserve, the result of being a newcomer to England: 'Mr. Brandt shows himself not only to be an artist but an anthropologist. He seems to have wandered about England with the detached curiosity

Bill Brandt *The English at Home* 1936

of a man investigating the customs of some remote and unfamiliar tribe.' Brandt was born into wealth in Hamburg and spent time in Switzerland, Austria and France. He had visited England in 1928 and settled in 1931. Mortimer's reference to art and anthropology was apt. That mix was at the heart of the poetic realism typical of much British documentary work in the interwar years. Poetic realism often adopted well-established visual devices, clichés even, that flattered the viewer with pictorial artfulness as a means to convince them of the social authority of the imagery.[5]

But a far more radical clash of art and anthropology could be found in Surrealism. The Surrealists approached the photographic document more dialectically. They understood it as a charged, enigmatic fragment that left as much unknown as it revealed, coaxing the viewer back onto their own judgment or imagination. This was an approach with which Brandt was more at ease. He remained unconvinced of the efficacy of the photograph as a means of straightforward social description and he was wary of its use within projects of social reform. As he grew older Brandt yielded ever more to his Surrealist impulses, but his work from the thirties is an unresolved and elusive mixture that frustrates any simple reading.

In the thirties Brandt was drawn to the rituals and customs of daily life, to what he saw as the deeply unconscious ways in which people inhabit their social roles. For him, to photograph these minutiae was not simply to document but to estrange through a heightened sense of atmosphere, theatrical artifice and a dreamlike sensibility. As an outsider he seemed to see English behaviour as bordering on passive automatism. Before his camera people look self-involved, fixed in their ways and slightly old-fashioned. There are very few traces of modernity in his work and few depictions of individuals as self-aware agents. Even when it was published, *The English At Home* was out of step. But in the last few decades it has become regarded as a classic work, not least because it is tempting to read in its mood a premonition. With hindsight we can see in it a picture of the insular English, unable to recognise their own image when they see it, sleepwalking into the nightmare of the Second World War, awoken all too close to disaster.

David Campany

In 1938 *Parlourmaid and Under-parlourmaid Ready to Serve Dinner* was
published in *Verve*, the English and French art and literature review.
It appeared opposite a reproduction of a painting by Henri Matisse of
a dinner table. Photography and painting were drawn into dialogue.
In July of the following year the English weekly magazine *Picture Post*
carried a photo-story titled 'The Perfect Parlourmaid'.[6] It comprises
a short text and 21 photographs by Brandt. Most of the images were
shot fresh for this assignment but a few were drawn from Brandt's
archive of shots taken in previous years. Each image is given a title
and caption. Across five pages the piece narrates the activities of a
head parlourmaid of a stately home, from half past six in the morning
to eight o'clock in the evening. She is the centre of each picture. We

see her as she prepares the Master's bath, starts to clean the silver, arranges the 'family's' breakfast, opens the drawing-room windows, superintends the housemaids, lays the luncheon table, tidies the top of the writing table, presides at the servants' lunch, opens the door to visitors, waits table at luncheon, lays the table for dinner, writes a letter home, chooses the silver, takes an afternoon off, does a little sewing, settles the details of the menu for dinner, oversees dinner, serves nightcaps in the drawing-room and finally sees that the house is safe. The 'day in the life' story was common in the illustrated press and in documentary film. Brandt himself had adopted it a few months before for *Picture Post* in a quite similar story about a young teasmaid. It was a comfortable, often conservative format that fitted documentary photography into a popular literary structure.

The photograph *Parlourmaid and Under-parlourmaid Ready to Serve Dinner* does not actually feature in this photo-essay. We cannot know for sure why this was but, looking at the other pictures, it seems there may have been something too forceful about this image. The other photographs in the story are less visually striking, less formally elegant. They adhere more closely to the familiar style of photo-essays. No image pretends to stand alone, each one opening on to the next like a cinematic edit. (Indeed, they have a feel typical of film stills and photo-novellas of the period.) More importantly *Picture Post* portrays the parlourmaid in a much more complex way than the famous single photograph. In the magazine she is shown to have an ambivalent position in the class structure of the pre-war wealthy home. While in the end belonging 'downstairs', the head parlour-maid had the confidence of the family. At dinner 'she hears every word that is spoken, yet she does not hear it', tells one caption. She is depicted as a trustworthy mediator, privy to the concerns of those upstairs *and* downstairs. Moreover, she is also shown as a representative of a new professional standing for women: head parlourmaids were beginning to replace male butlers, a change that probably prompted the story to be commissioned. The introduction states '1,332,224 persons are employed in domestic service in England and Wales. There are no separate statistics for parlourmaids, but with house-parlourmaids, they are said to number about 20,000.' In this sense the head parlourmaid is shown as part of an old class structure

David Campany

but a sign of new trends too. Brandt had first photographed her in 1933, six years before her appearance in *Picture Post*. Her role must have been even more unusual then. Little of this is evident in the famous single image, which, perhaps by default, we assume shows us a situation typical of its time.

Like many of his apparently documentary images, the *Picture Post* story was a family affair. It is Bill's brother Rolf who is served dinner in the final image. The parlourmaid went by the name of Pratt and she was in charge of the two residences owned by the brothers' uncle, the banker Henry Brandt.[7] He owned a home in Mayfair and another in Redhill, Surrey, where most of the photos were shot. Bill frequently made use of friends and family in his photographs, many of which required careful forethought and staging.

In the 1930s and early 1940s Brandt produced many photo-stories for *Weekly Illustrated*, *Picture Post* and its brother publication *Lilliput*. Yet he seems to have somewhat stumbled into his work as a photo-journalist, and had all but given it up by the mid-1940s. In 1948 he wrote: 'Towards the end of the war, my style changed completely. I have often been asked why this happened. I think I gradually lost my enthusiasm for reportage. Documentary photography had become fashionable. Everybody was doing it. Besides, my main theme of the past few years had disappeared; England was no longer a country of marked social contrast.'[8] England after the war was still a country steeped in social division, despite the need for cooperation and the hope for a collective rebuilding. What *had* gone was the clear visibility of those divisions. As the photographer August Sander had found in Germany after the war, clothing and gesture were no longer so obviously marked by social position or profession. Appearances were levelling out and 'reading' people from their surfaces had become much more difficult.

By the 1940s Brandt had done his youthful, energetic work. Despite his early 'enthusiasm for reportage' he had always struggled with the pictorial form of the photo-essay. His forte was the singular image that worked best alone or in simple juxtaposition. Each Brandt photograph aims for a tight formal organisation, its content given dramatic charge and dense psychological resonance. As documents his photographs aim unapologetically to exceed visual description.

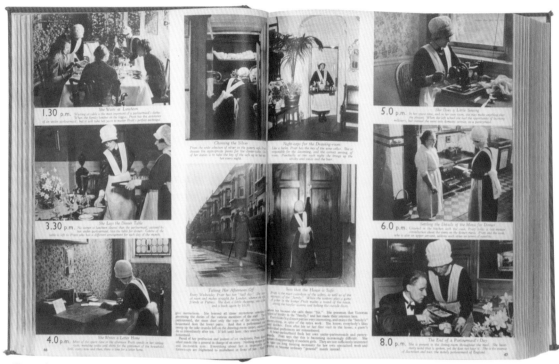

Bill Brandt *Picture Post*,
vol. 4, no 4, 29 July 1939

However, what served Brandt ill as a photojournalist was just what predisposed his images towards posterity. Not surprisingly, this preference for the self-contained image is shared by many of the documentarists and photojournalists who pursued their paid work as artists. When we think of Henri Cartier-Bresson, for example, what come to mind are the great single pictures – his 'decisive moments' of pictorial geometry and poetic expression. His photo-essays for magazines are much less celebrated. Similarly the American Walker Evans worked within reportage but with 'higher' artistic aims. *Picture Post* has long since vanished, its undeniably powerful place in British society a dimming memory. An issue of a weekly magazine had a cultural life little longer than its initial seven days. Its impact would be widespread but brief. Brandt's images have lived on in the more robust histories of photography and art that were taking shape just as he was turning away from reportage.

In the 1950s Brandt continued to work professionally but concentrated on the more established genres of portraiture and landscape. Then in the 1960s there were two major changes in his work and its reception. Both were related to his emerging position in art photography. He began to print his negatives much more harshly, sacrificing the mid-tones for more modish graphic blocks of black and white. The rich descriptive information in his negatives would be subsumed, even obliterated in his new aesthetic. While his latest photography was pursued more openly as art, notably in his nudes, his expressionism was released anew upon his earlier work. His books from the 1960s are also printed this way. The large-format anthology *Shadow of Light* (1966) selected photographs spanning his career, with an emphasis on the singular print and Brandt as a single-minded visionary. This was the book that made the case for his position in twentieth-century art. The idea of a working photographer is somewhat sidelined in favour of the persona of an intuitive artist, which perhaps he had always wanted to be.

Nevertheless artwork and document are never entirely separate. *Parlourmaid and Under-parlourmaid Ready to Serve Dinner* is included in *Shadow of Light*, this time opposite a photograph titled *In a Kensington Drawing Room after Dinner*. The spread echoes that first juxtaposition made in *The English At Home* thirty years before. Another two images of Pratt

from the *Picture Post* story are also included. In one case *Picture Post* had captioned an image 'Taking her afternoon off', visiting friends in Putney. In *Shadow of Light* the same shot is titled *Putney Landlady*. Words could make her stern face mean many things in Brandt's typically slippery use of the social document.

The reprinting of *Parlourmaid and Under-parlourmaid Ready to Serve Dinner* was never *too* harsh. Brandt knew well that the power of this photograph resides in its details. *Shadow of Light* even improved on its past reproductions, allowing new layers of meaning to emerge. We can now see more clearly that in taking this shot Brandt deliberately focused on the shiny glass and silverware of the dining table. The parlourmaids behind are not so crisp. It may have been that the whole scene could not have been rendered in detail for technical reasons. Presented with two options Brandt chose to let the faces fall away. We can still see that they avoid 'eye contact' with the camera – as if averting their gaze from their master. They know their place. The camera clearly 'sees' them but fails to focus on them. What is the effect of this? It is difficult to say exactly. Does Brandt put us in the position of the master of the house, keener to scrutinise the dinner table than to connect with the other people in the room? Perhaps, but in doing this he opens up a commentary, a critical distance, on the whole scenario. We are presented with the maids out of focus technically and, by extension, *socially*. Their being out of focus becomes the focus of the picture, so to speak. Rarely in the history of the medium has this optical effect opened up such complexity. While some meanings of the photograph have been buried as the image has moved across time and from documentary to art, new ones have come to the surface.

In 1969 the American photographer Walker Evans selected a handful of photographs to summarise artistic quality in the medium. He included *Parlourmaid and Under-parlourmaid Ready to Serve Dinner*. 'This picture is Brandt striking home (in all senses of the word)', he wrote. 'Instantaneous precision is only the beginning of its quality; it proceeds to a lot more; surgical detachment, wit, theater. . .'.[9] That year, at the age of 65, Brandt had a major show at New York's Museum of Modern Art which came to London's Hayward Gallery in 1970. The catalogue reproduced 13 of the show's 125 images, including

David Campany

Parlourmaid and Under-parlourmaid Ready to Serve Dinner, further establishing Brandt and the status of this image.

As with many photographers who were discovered by a wide audience later in life, Brandt found himself regarded as a 'figure from the past' and as a contemporary artist at the same time. Layered on top of this was what looked like a shift from documentarist to artist. The reality, as always, was more complicated. At his best he was a 'documentary artist' with all the paradoxes and interpretative difficulties that entails. There could never be any simple distinction between his artistry and his documentary description. The two are inextricable and give us no clear answers. And in the end it is the contradictions at the heart of his work that are the bedrock of his success.

Edgar Anstey and **Arthur Elton**
Housing Problems 1935

Julian Trevelyan *Teapot Café*
c.1937–8

Humphrey Spender
Pub Interior c.1937–8

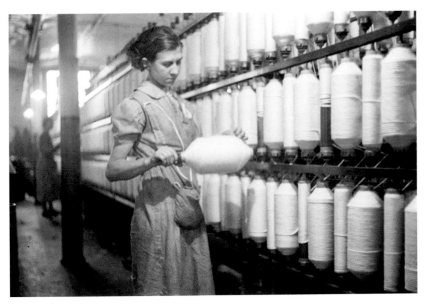

Humphrey Spender *Interior –*
Textile Mills c.1937–8

Edith Tudor Hart

Demonstration, South Wales

c.1934

Wolfgang Suschitzky
Lyons Corner House,
Tottenham Court Road c.1934

Henry Moore
Grey Tube Shelter 1940

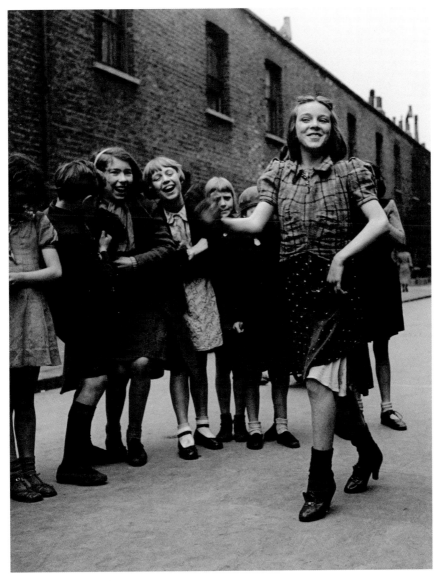

Bill Brandt *East End Girl Dancing
the Lambeth Waltz* 1939

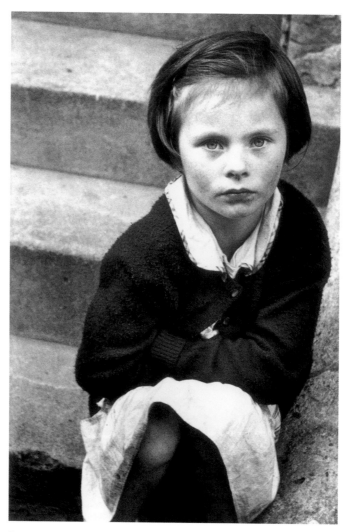

Roger Mayne *Girl on the steps,*
St Stephen's Gardens,
Westbourne Park 1957

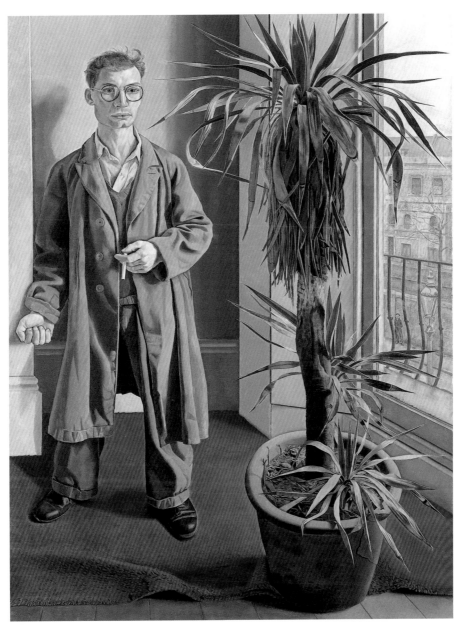

Lucian Freud *Interior in Paddington* 1951

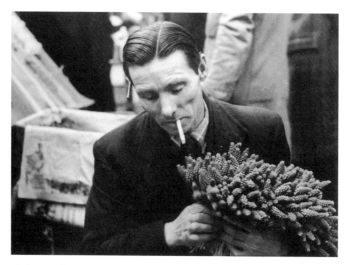

Lindsey Anderson *Every Day Except Christmas* 1957

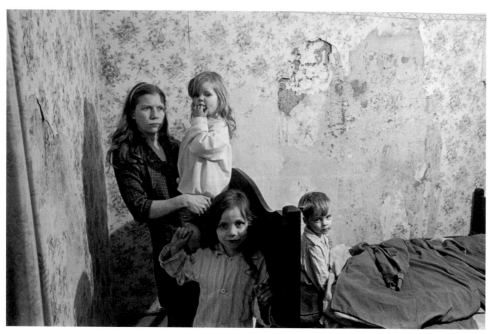

Nick Hedges *Mother and children, Balsall Heath* 1969

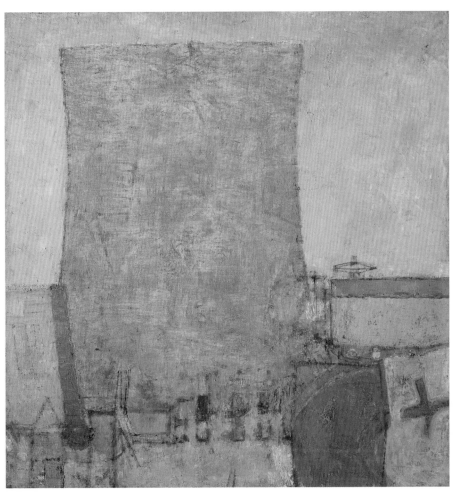

Prunella Clough
Cooling Tower II 1958

Nigel Henderson *Wig Stall,*
Petticoat Lane 1952

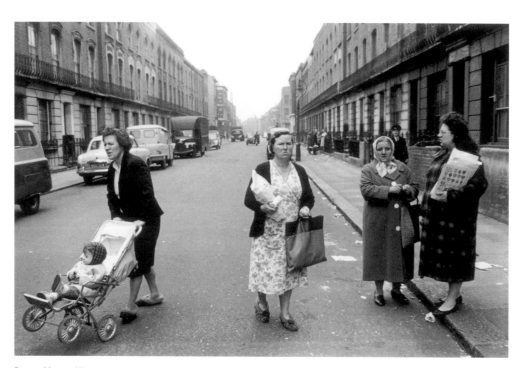

Roger Mayne *Women,*
Southam Street, North Kensington,
London 1961

Tony Ray-Jones *Glyndebourne*
Festival 1967

Tony Ray-Jones *Dickens Festival,*
Broadstairs 1967–68

John Bratby *Still Life with Chip Frier* 1954

Michael Andrews *People on
the Beach (August for the People)*
1951

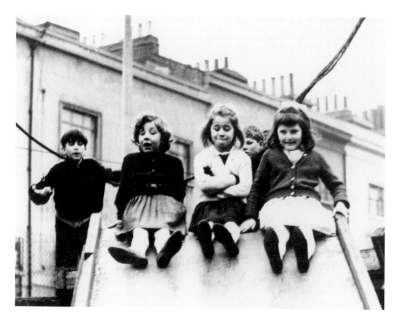

Paul Almond and **Michael Apted**
Seven Up 1964

Paul Watson and **Franc Roddam**
The Family 1974

```
 6:15 AM: GET UP, MAKE
          BREAKFAST
 7:30 AM: CALL DAUGHTER
 7:35 AM: LEAVE HOME
 8:00 AM: START WORK
12:30 PM: FINISH WORK
          SHOPPING
 1:05 PM: ARRIVE HOME
          LUNCH, REST
 1:45 PM: DO HOUSEWORK
 4:30 PM: PREPARE DINNER
          WASH UP
 6:30 PM: SIT DOWN
 7:30 PM: HUSBAND'S DINNER
 8:30 PM: IRONING
10:00 PM: MAKE COFFEE
11:30 PM: GO TO BED

ELENA JONES   AGE 54
1 SON AGE 17 1 DAUGHTER AGE 11

RIVET MACHINE OPERATOR
PART-TIME 8:00 AM: - 12:30 PM:
```

Margaret Harrison, Kay Hunt
and **Mary Kelly** *Women and
Work: A Document on the
Division of Labour in Industry
1973–75* 1973–75 (detail)

John Davies *Agecroft Power
Station, Salford 1983*

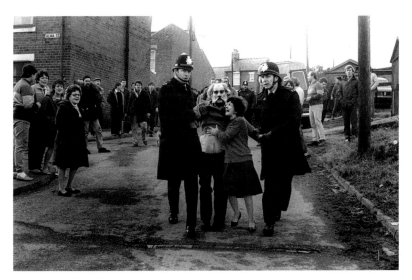

Keith Pattison *Arrest of Josie Smith,
a retired, disabled miner, during police
efforts to escort returning miners
back to work* 1984

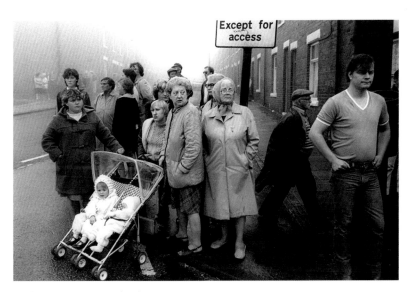

Keith Pattison *Families of striking miners
look on as police seal off the pit and
escort the first returning miner back to
work. Easington Colliery, Co. Durham* 1984

Rita Donagh *Bystander* 1977

William Raban *Thames Film* 1986

Paul Graham *Queue, Paddington*
DHSS West London, 1985

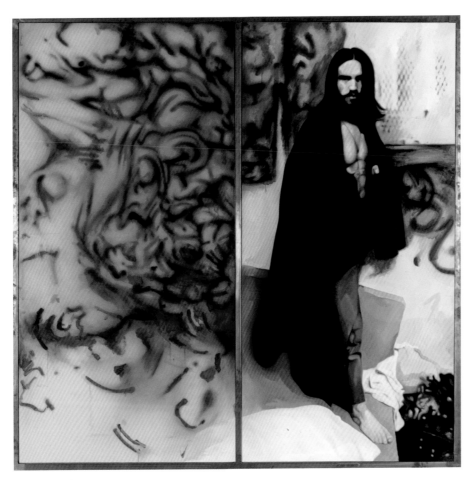

Richard Hamilton
The citizen 1981–3

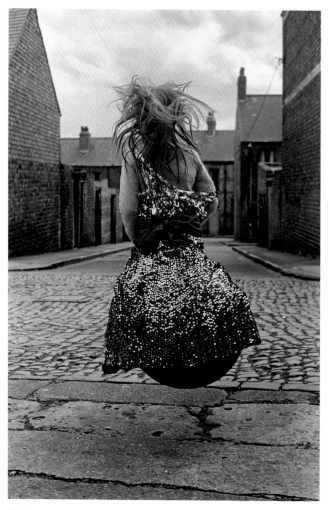

Sirkka-Liisa Konttinen
Girl on a 'spacehopper', Janet
Street backlane 1971

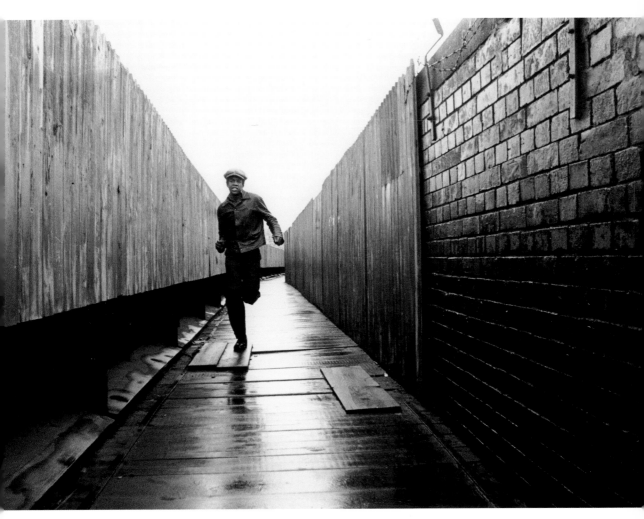

Horace Ové *Pressure* 1975

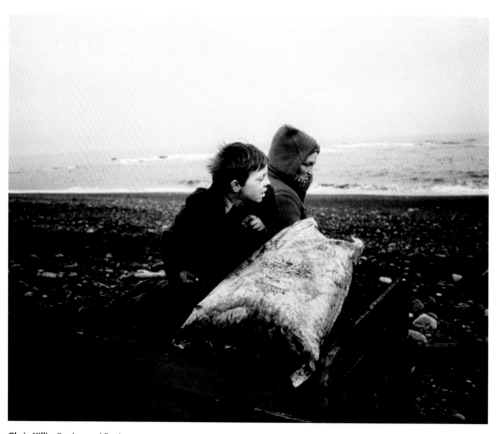

Chris Killip *Rocker and Rosie,*
Lynemouth, Northumberland 1984

Martin Parr *The Last Resort 23*
1983–6

Richard Billingham *Untitled* 1996

Willie Doherty *Incident* 1993

Nathan Coley *Lockerbie*
Evidence #4 2003

Gillian Wearing *10–16* 1997

Isaac Julien *Paradise Omeros* 2002

Notes

TANYA BARSON: TIME PRESENT AND TIME PAST

1 John Grierson, 'First Principles of Documentary', in *Grierson on Documentary*, edited with an introduction by Forsyth Hardy, London, Faber and Faber, 1979, p. 37.

2 Another significant film maker and theorist of documentary was Paul Rotha. Following a stint in the United States, Grierson returned to Britain and in 1927 joined the newly formed Empire Marketing Board Film Unit (1927–33) as an Assistant Films Officer. After the EMB Film Unit was abolished he moved to the General Post Office Film Unit (1933–39) as Film Officer. He stayed at the GPO until 1936, after which Alberto Cavalcanti took over. In 1939, with the outbreak of the Second World War, the unit was transferred to the Ministry of Information and became the Crown Film Unit, with a remit to produce propaganda.

3 In a 1926 article on the American filmmaker Robert Flaherty, Grierson commented that Flaherty's *Moana* 1926, a poetic ethnographic film, had 'documentary value'. Before this such films were known as 'actuality' films, although Grierson said that the term was used in France to refer to travelogues. Grierson quoted by Forsyth Hardy in his introduction to *Grierson on Documentary*, p. 11.

4 Grierson, 'First Principles of Documentary', p. 36.

5 See Ian Aitken, *Film and Reform: John Grierson and the Documentary Film Movement*, London and New York, Routledge, 1990, p. 77.

6 Ibid., p. 116.

7 Grierson's work should be seen in a broader context given his background: his family were Scottish, liberal, Fabians, and Grierson was versed in Carlyle's and Ruskin's social values, Kant's idealist aesthetics and the Marxist critique of formalism.

8 *Drifters* was first screened by the Film Society on 10 November 1929 alongside Eisenstein's *Battleship Potemkin* 1925, a film which was at that time banned from public screening in Britain, and Cavalcanti's *Rien que les heures* 1926. As Aitken points out, it 'established Grierson and the EMB Film Unit as a significant force in filmmaking' (*Film and Reform*, p. 2).

9 Quoted in Bruce Laughton, *William Coldstream*, New Haven and London, Yale University Press, 2004, p. 28.

10 Although at this time Coldstream turned away from film, he was later responsible for establishing a film department at the Slade School of Art and was chairman of the BFI.

11 David Mellor, 'Mass Observation', in *Ciudad: PHE05*, Madrid, PHotoEspaña Guide, 2005, p. 236.

12 Published in the magazine *Lilliput* in 1943.

13 Paul Delany, *Bill Brandt: A Life*, London, Jonathan Cape/Pimlico, 2004, p. 175.

14 See Duncan Forbes, 'Politics, Photography and Exile in the Life of Edith Tudor-Hart (1908–1973)', in Shulamith Behr and Marian Malet (eds.), *Arts in Exile in Britain 1933–1945: Politics and Cultural Identity*, Yearbook of the Research Centre for German and Austrian Exile Studies, Amsterdam and New York, Editions Rodopi, 2005.

15 Lindsay Anderson, 'Only Connect: Some Aspects of the Work of Humphrey Jennings' (1954), in Richard Meram Barsam (ed.), *Nonfiction Film Theory and Criticism*, New York, E. P. Dutton & Co., 1976, p. 264.

16 Lindsay Anderson, 'Free Cinema' (1950), in Barsam (ed.), *Nonfiction Film Theory*, p. 72.

17 Ibid., p. 72.

18 Both films were sponsored by the Ford Motor Company as part of the non-advertising documentary series *Look at Britain*.

19 Tony Richardson and John Osborne collaborated on the 1959 film version of Osborne's play *Look Back in Anger*. This and many of the films that are synonymous with the 'kitchen sink' movement were made by Woodfall Films, the production company set up by Richardson and Osborne.

20 As Director of the British Film Institute in the 1950s, Forman had encouraged Lorenza Mazzetti, then studying at the Slade School of Art, to apply for a grant from the BFI Experimental Film Fund to make the fictional film *Together* 1956. The cast of *Together* included Mazzetti's fellow Slade students Michael Andrews and Eduardo Paolozzi.

21 See Laughton, *William Coldstream*, pp. 164–5.

22 Henderson's photographs of the Samuels family relate to his wife Judith Henderson's 'Discover Your Neighbour' project, itself similar to Mass-Observation.

23 Quoted in Mark Haworth Booth, *The Street Photographs of Roger Mayne*, London, Victoria and Albert Museum, 1986, p. 70.

24 Roger Mayne, 'The Realist Position', from Upper Case 1961, reprinted in *Roger Mayne Photographs*, introduction by Ray Gosling, London, Jonathan Cape, 2001, p. 18.

25 Stuart Hall, 'Vanley Burke and the "Desire for Blackness"', in Mark Sealy (ed.), *Vanley Burke: A Retrospective*, London, Lawrence and Wishart, 1993, p. 12.

26 Ibid., p.14.

27 Michael Bracewell, 'Writing the Modern World', in *Gilbert and George Dirty Words Pictures*, London, Serpentine Gallery, 2002, pp. 12–13.

28 In 1977 the National Front marched through London, answered by demonstrations by the Anti-Nazi League and Socialist Workers' Party.

29 Interview by Douglas Fogle, reprinted in *Brilliant! New Art from London*, Minneapolis, Walker Art Center, 1995, p. 81.

30 Jeremy Deller in *The English Civil War: Part II: Personal Accounts of the 1984–85 Miners' Strike*, London, Artangel, 2002, p. 6.

31 Ibid., p.6.

32 Isaac Julien, '*Paradise Omeros*', in *Documenta 11: Platform 5 Exhibition*, exh. cat., Ostfildern-Ruit, Hatje Cantz Publishers, 2002, p. 572.

33 Grierson, 'First Principles of Documentary', p. 35

LYNDA MORRIS: THE TOUCH OF TIME

1 In W.H. Auden and Louis MacNiece, *Letters from Iceland*, 1937.

2 See David Mellor (ed.), *Germany: The New Photography 1927–33: Documents and Essays*, London, Arts Council of Great Britain, 1978.

3 See W.L. Guttsman, *Art for the Workers*, Manchester, Manchester University Press, 1997.

4 R.S. Lambert (ed.), *Art in England*, London, Pelican, 1938, pp. 99–104.

5 *The Spectator*, 25 March 1938. See also Lynda Morris, 'Anthony Blunt and the Arguments for Realism', *Art Monthly*, nos. 35 and 36, 1980; 'Coldstream and Representational Painting', *Art Monthly*, no. 79, Sept. 1984.

6 See Johann Peter Eckermann, *Conversations with Goethe*, London, Everyman (Dent Publishing), 1973; Helen Lessore in Lynda Morris (ed.), *Henry Tonks and the Art of Pure Drawing*, Norwich, Norwich Gallery, 1985.

7 See Mike Davies, *Late Victorian Holocausts*, London, Verso, 2001.

8 See also Lynda Morris (ed.), *Nigel Henderson Bethnal Green Photographs 1949–51*, Nottingham, Midland Group, 1978, with the diary by his wife Judith Stephens, a social anthropologist, about their neighbours.

9 An unpublished taped interview with Richard Carline talking to Lynda Morris c.1984 is in the Tate AIA Archives. He talks about the role of the US in the development of UNESCO after 1945. A file survives in the AIA Archive at the Tate gallery of the artists invited to show in the exhibition.

10 See Lynda Morris and Robert Radford, *The Story of the Artists' International Association 1933 to 1953*, Oxford, MOMA, 1983.

11 Frederick Antal, *Florentine Painting and its Social Background*, London, Routledge & Kegan Paul, 1947.

12 F.D. Klingender, *Marxism and Modern Art*, London, Lawrence and Wishart, 1943, reprinted 1977.

13 'The Ways Out of Abstraction', *The Spectator*, 22 January 1937.

14 See 'Mr Oldham and his Guests by Highmore', *The Burlington Magazine*, May 1949.

15 'Courbet the Pioneer', *The Listener*, 23 October 1947; 'Holbein the Painter', *The Listener*, February 1947, p. 239.

16 Evelyn Antal in interview with Lynda Morris, 1983.

17 *The Townsend Journals 1928–51*, edited by Andrew Forge, London, Tate Gallery, 1976.

18 Memorial Meeting for Coldstream, Bartlett Lecture Theatre, University College London, 1987.

19 Quoted from 'Deuxième Entretien avec Alberto Giacometti' in Georges Charbonnier, *Le Monologue du Peintre*, Paris, Juillard, 1959, pp. 171–83.

20 Richter said this to the author, on his way to meet Hamilton in New York in autumn 1973 at the time of Hamilton's Guggenheim Retrospective and Richter's first New York exhibition, organised by Konrad Fischer for the Onnasch Gallery. They knew each other's work through both showing with René Block in Berlin but they had never met.

MARK NASH: UN-MAKING HISTORY: THOUGHTS ON THE RE-TURN TO DOCUMENTARY

1 See the excellent BFI resources in this area: Patrick Russell, 'Documentary Film Units and Film Sponsorship', http://www.screenonline.org.uk/film/id/964488, accessed 29 October 2005.

2 Bert Hogenkamp, *Deadly Parallels: Film and the Left in Britain, 1929–39*, London, Lawrence and Wishart, 1986 is an important source of information for this period.

3 Coal mining features heavily in the photographic work in this show; see for example the images by Keith Pattison, Henry Moore and Bill Brandt.

4 In the 1930s and 1940s, for instance, John Grierson's sister Ruby had directed and edited documentaries but to less acclaim than her brother.

5 Eternally, because the film plays as a loop.

6 Slocombe had begun as a photographer on wartime newsreels and documentaries such as *Lights Out in Europe* and *The Big Blockade* (both 1940).

DAVID CAMPANY: THE CAREER OF A PHOTOGRAPHER, THE CAREER OF A PHOTOGRAPH: BILL BRANDT'S ART OF THE DOCUMENT

1 Juxtapositions across the double page had been a staple of the German magazine *Der Querschnitt*, and the device soon spread to publications such as the American *Coronet* and the English *Lilliput*. Brandt took a copy of *The English At Home* to Tom Hopkinson, then the assistant editor at *Weekly Illustrated* magazine. Hopkinson liked the book and Brandt received commissions. Often these involved the simple class contrasts that had become common in the popular press. His piece 'Topper versus Bowler' in July 1936 was typical. Later Stefan Lorant, editor of *Lilliput*, used Brandt's images in satirical pairings with other photos. See David Mellor's introductory essay in *Bill Brandt*, London, Royal Photographic Society, 1981.

2 Mark Haworth-Booth cites Henderson in his introduction to the second edition of Brandt's book *Shadow of Light*, London, Gordon Fraser, 1977, p. 17.

3 John Taylor, 'Picturing the Past: Documentary Realism in the 30s', *Ten8*, no. 11, 1982, p. 30.

4 In recent years *The English At Home* has been included in two surveys of significant photographic books: Andrew Roth's *The Book of 101 Books: Seminal Photographic Books of the Twentieth Century*, New York, PPP Editions in association with Roth Horowitz LCC, 2001, and Martin Parr and Gerry Badger's *The Photobook: A History, Volume One*, London, Phaidon Press, 2004.

5 Poetic realism as a documentary form was to be subject to thoroughgoing critique in later years, notably from Alan Sekula, who argued that in such a strategy '[pity], mediated by an appreciation of great art, supplants political understanding'. Alan Sekula, 'Dismantling Modernism, Reinventing Documentary', in *Photography Against the Grain*, Nova Scotia, Nova Scotia College of Art and Design, 1984, pp. 53–75.

6 'The Perfect Parlourmaid', *Picture Post*, vol. 4, no. 4, 29 July 1939, pp. 43–7. *Picture Post* ran from 1938 to 1957. At its height it sold 1,350,000 copies per week. It was owned by Edward G. Hulton and edited for its first year or so by the emigré Stefan Lorant and thereafter by Tom Hopkinson. Hulton was an active member of the Conservative Party while Lorant and Hopkinson had broadly socialist principles. The politics of the magazine were complex. It was staunchly anti-Nazi; domestically it campaigned for full employment, minimum wages, child allowances, educational reform and a national health service. At the same time its portrayal of the British class system was often unwittingly conservative, particularly in its depiction of the industrial North of England. Indeed it contributed in many ways to the entrenched regional stereotypes that are still with us. See Stuart Hall, 'The Social Eye of Picture Post', *Working Papers in Cultural Studies*, no. 2, 1972; Taylor, 'Picturing the Past'; and Sylvia Harvey, 'Who Wants to Know What and Why', *Ten8*, no. 23, 1986, pp. 26–31.

7 It seems Brandt sensed right away that Pratt would make an interesting subject. He had made a note about his first meeting with her in 1928: 'Fortuite ou nécessaire – qui sait – la rencontre avec Pratt m'était en tous cas fatale' ('Fortuitous or determined – who knows – the meeting with Pratt was in any case a fatal/fateful one for me'). See Paul Delany, *Bill Brandt: A Life*, London, Jonathan Cape, 2004, p. 106.

8 Bill Brandt, 'Introduction' to his *Camera in London*, London, Focal Press, 1948. This book, with its slightly sentimental edit of his past work, is one of the few Brandt publications not to contain *Parlourmaid and Under-parlourmaid Ready to Serve Dinner*.

9 Walker Evans in Louis Kronenberger (ed.), *Quality: Its Image in the Arts*, New York, Atheneum, 1969, p. 98.

List of exhibited works

Amber

Launch 1973
16mm film transferred to DVD
col 10 mins
Side Gallery, Newcastle

Lindsey Anderson

Every Day Except Christmas 1957
16mm film transferred to DVD
b/w 40 mins
British Film Institute, National Film
and Television Archive

Michael Andrews

People on the Beach (August for
the People) 1951
Oil on board
143.5 × 122 cm (56 × 47½ inches)
UCL Art Collections, University
College London

Edgar Anstey and
Arthur Elton

Housing Problems 1935
16mm film transferred to DVD
b/w 15 mins
British Film Institute, National Film
and Television Archive

Michael Apted

21 Up 1977
16mm film transferred to DVD
col 100 mins
Granada International

Cyril Arapoff

East End Children c.1935
Silver gelatine print
19.5 × 16 cm (7½ × 6¼ inches)
Lent by the Museum of London

*Mr Mix with his Children, Hanbury
Building, Poplar* 1939
Silver gelatine print
21.1 × 16.6 cm (8¼ × 6½ inches)
Lent by the Museum of London

*Children Playing on the beach
near Tower Bridge* c.1934
Silver gelatine print
16.5 × 17.5 cm (6½ × 6¾ inches)
Lent by the Museum of London

Graham Bell

Thomasen Park, Bolton 1938
Oil on canvas
50.9 × 61 cm (20 × 23¾ inches)
Yale Center for British Art
Paul Mellon Fund

**Berwick Street
Film Collective**

Nightcleaners 1975
16mm film transferred to DVD
col. 90 mins
Courtesy of Mary Kelly, James
Scott, Humphry Trevelyan and
the Estate of Marc Karlin/LUX

Richard Billingham

Untitled 1995
Colour photograph on aluminium
80 × 120 cm (31¼ × 46¾ inches)
Courtesy of the artist and
Anthony Reynolds Gallery, London

Untitled 1995
Colour photograph on aluminium
120 × 80 cm (46¾ × 31¼ inches)
Courtesy of the artist and
Anthony Reynolds Gallery, London

Untitled 1996
Colour photograph on aluminium
105 × 158 cm (41 × 61½ inches)
Courtesy of the artist and
Anthony Reynolds Gallery, London

**Black Audio Film
Collective** and
John Akomfrah

Handsworth Songs 1986
16mm film transferred to DVD
col 61 mins
British Film Institute, National Film
and Television Archive

Bill Brandt

*Parlourmaid and Under-parlour-
maid Ready to serve Dinner* 1933
Silver bromide print
38 × 32.5 cm (15 × 12¾ inches)
Arts Council Collection, Hayward
Gallery, South Bank Centre,
London

Young Housewife, Bethnal Green
1937
Gelatin silver print
33.1 × 28.9 cm (13 × 11¼ inches)
Victoria and Albert Museum

Parlourmaid preparing a bath 1933
Gelatin silver print
34 × 29 cm (13¼ × 11¼ inches)
Victoria and Albert Museum

*East End Girl dancing the Lambeth
Waltz* 1939
Gelatin silver print
33.5 × 28.7 cm (13 × 11¼ inches)
Victoria and Albert Museum

A Snicket in Halifax c.mid-late
1930s
Gelatin silver print
33.8 × 29cm (13¼ × 11¼ inches)
Victoria and Albert Museum

Halifax 1937
Gelatin silver print
34 × 28.9cm (13¼ × 11¼ inches)
Victoria and Albert Museum

Cocktails in a Surrey Garden 1938
Gelatin silver print
34.3 × 29.2 cm (13½ × 11½ inches)
Marlborough Fine Art

*East Durham Miner Just Home
from the Pit* c.1937
Gelatin silver print
34.3 × 29.2 cm (13½ × 11½ inches)
Marlborough Fine Art

Children in Sheffield 1937
Gelatin silver print
34.3 × 29.2 cm (13½ × 11½ inches)
Marlborough Fine Art

Eton Sprawls 1936
Gelatin silver print
34.3 × 29.2 cm (13½ × 11½ inches)
Marlborough Fine Art

*South West London underground
garage shelter* 12.11.1940
Silver gelatine print
24.7 × 19.3 cm (9½ × 7½ inches)
Lent by the Museum of London

*East End underground station
shelter* 12.11.1940
Silver gelatine print
24.8 × 19.6 cm (9½ × 7½ inches)
Lent by the Museum of London

East End underground station shelter 12.11.1940
Silver gelatine print
25.2 × 19.7 cm (9¾ × 7½ inches)
Lent by the Museum of London

Clive Branson

Portrait of a Worker c.1930
Oil on canvas
support: 61 × 25 × 1.6 cm
(23¾ × 9¾ × ½ inches)
frame: 73.6 × 37.8 × 3.7 cm
(28¾ × 14¾ × 1½ inches)
Bequeathed by Noreen Branson
2004
Tate

Selling the 'Daily Worker' outside Projectile Engineering Works 1937
Oil on canvas
40.6 × 50.8 cm
(15¾ × 19¾ inches)
Bequeathed by Noreen Branson
2004
Tate

John Bratby

Still Life with Chip Frier 1954
Oil on board
131.4 × 92.1 cm (51½ × 36 inches)
Presented by the Contemporary
Art Society 1956
Tate

The Toilet 1955
Oil on board
117.1 × 87.2 cm (45¾ × 34 inches)
Purchased 1993
Tate

Vanley Burke

Couple Dancing at a Birthday Party c.1970–79
Black and white photograph
60.9 × 41.4 cm (24 × 16 inches)
Courtesy of Vanley Burke

The Boy with the Flag c.1970–79
Black and white photograph
60.9 × 41.4 cm (24 × 16 inches)
Courtesy of Vanley Burke

Handsworth Market, Wig Stall c.1970–79
Black and white photograph
60.9 × 41.4 cm (24 × 16 inches)
Courtesy of Vanley Burke

Red Lion Bar, Soho Road c.1970–79
Black and white photograph
41.4 × 60.9 cm (16 × 24 inches)
Courtesy of Vanley Burke

Wasiffa Sound System, Handsworth Park c.1970–79
Black and white photograph
41.4 × 60.9 cm (16 × 24 inches)
Courtesy of Vanley Burke

Handsworth Park, Cricket c.1970–79
Black and white photograph
41.4 × 60.9 cm (16 × 24 inches)
Courtesy of Vanley Burke

Portrait of a Bridesmaid c.1970–79
Black and white photograph
60.9 × 41.4 cm (24 × 16 inches)
Courtesy of Vanley Burke

Africa Liberation Day c.1970–79
Black and white photograph
41.4 × 60.9 cm (16 × 24 inches)
Courtesy of Vanley Burke

Handsworth Riots 1985
Black and white photograph
41.4 × 60.9 cm (16 × 24 inches)
Courtesy of Vanley Burke

Day Trip to Skegness c.1980–89
Black and white photograph
41.4 × 60.9 cm (16 × 24 inches)
Courtesy of Vanley Burke

Alberto Cavalcanti

Coalface 1935
16mm film transferred to DVD
b/w 11 mins
British Film Institute, National Film and Television Archive

Prunella Clough

Cooling Tower II 1958
Oil on canvas
96.5 × 91.4 cm
(37½ × 35½ inches)
Purchased 1960
Tate

Man Hosing Metal Fish Boxes 1951
Oil on canvas
92.1 × 52 cm (36 × 20¼ inches)
Accepted in lieu of tax and allocated to the Tate Gallery 1993
Tate

William Coldstream

Bolton 1938
Oil and graphite on canvas
71.3 × 91.3 cm
(27¾ × 35¼ inches)
National Gallery of Canada, Ottawa
Gift of the Massey Collection of English Painting, 1946

W.H. Auden c.1938
Oil on canvas
90.8 × 71.5 cm (35½ × 28 inches)
Harry Ransom Humanities Research Centre, The University of Texas at Austin

Man with a Beard 1939
Oil on canvas
61 × 40.6 cm (23¾ × 15¾ inches)
Presented by the Trustees of the Chantrey Bequest 1940
Tate

On the Map 1937
Oil on canvas
50.8 × 50.8 cm (20 × 20 inches)
Purchased 1980
Tate

Havildar Ajmer Singh 1943
Oil on canvas
support: 78.7 × 56.5 cm
(30¾ × 22 inches)
Presented by the War Artists Advisory Committee 1946
Tate

Rifleman Mangal Singh: 2/6 Rajput Rifles 1943–4
Oil on canvas
60.9 × 48.2 cm
(23¾ × 18¾ inches)
Imperial War Museum, London

Nathan Coley

I Don't Have Another Land 2002
Stained wood and mixed media
130 × 160 × 160 cm
(50¾ × 62½ × 62½ inches)
Courtesy of the artist and Haunch of Venison Gallery, London

Lockerbie Evidence #3 2003
Coloured pencil on paper
59.5 × 84 cm (23¾ × 32¾ inches)
Courtesy of the artist and Haunch of Venison Gallery, London

Lockerbie Evidence #4 2003
Coloured pencil on paper
59.5 × 84 cm (23¾ × 32¾ inches)
Courtesy of the artist and Haunch of Venison Gallery, London

Lockerbie Evidence #16 2003
Coloured pencil on paper
59.5 × 84 cm (23¾ × 32¾ inches)
Courtesy of the artist and Haunch of Venison Gallery, London

Lockerbie Evidence #31 2003
Coloured pencil on paper
59.5 × 84 cm (23¾ × 32¾ inches)
Courtesy of the artist and Haunch of Venison Gallery, London

John Davies

Walkley Sheffield 1981
Silver gelatin print
39.9 × 58.4cm (15.7 × 23 inches)
Courtesy of the artist

Monkwearmouth Colliery 1983
Silver gelatin print
39.9 × 58.4cm (15.7 × 23 inches)
Courtesy of the artist

Easington Colliery 1983
Silver gelatin print
39.9 × 58.4cm (15.7 × 23 inches)
Courtesy of the artist

Agecroft Power Station, Salford 1983
Silver gelatin print
39.9 × 58.4cm (15.7 × 23 inches)
Courtesy of the artist

Jeremy Deller

The Battle of Orgreave Archive (An Injury to One is an Injury to All) 2004
Mixed media
Display dimensions variable
Courtesy of the artist, The Modern Institute

Willie Doherty

Tell Me What You Want 1996
Video installation on two monitors
Display dimensions variable
Presented by the Patrons of New Art (Special Purchase Fund) through the Tate Gallery Foundation 1999
Tate

Remote Control 1992
Black and white photograph on photographic paper
122 × 183 cm (47 ½ × 71 ½ inches)
Purchased from Matt's Gallery
(General Funds) 2003
Tate

Incident 1993
Cibachrome print on paper on aluminium
122 × 180 cm (47 ½ × 70 ¼ inches)
Lent by the American Fund for the Tate Gallery, courtesy of Carolyn Alexander 2002
Tate

Rita Donagh

Bystander 1977
Oil and collage on canvas
152 × 152 cm (59 ¼ × 59 ¼ inches)
Courtesy of Rita Donagh

Philip Donnellan

The Colony 1964
16mm film transferred to DVD
b/w 57 mins
British Film Institute, National Film and Television Archive

Mike Figgis

'The Battle of Orgreave' Jeremy Deller 2001
Video transferred to DVD
col 60 mins
Display dimensions variable
Co-commissioned by Artangel and Channel 4
Courtesy Artangel

Lucian Freud

Girl with a White Dog 1950–1
Oil on canvas
76.2 × 101.6 cm
(29 ¾ × 39 ½ inches)
Purchased 1952
Tate

Interior in Paddington 1951
Oil on canvas
152.4 × 114.3cm
(59 ½ × 44 ½ inches)
Walker Art Gallery, National Museums Liverpool

Gilbert and George

Coronation Cross 1981
Paper on board
133 × 99.7 cm (52 × 39 inches)
Purchased 1982
Tate

Cunt Scum 1977
Photograph on paper
241.3 × 200.7 cm
(94 × 78 ¼ inches)
Presented anonymously 1998
Tate

Lawrence Gowing

Mrs Roberts 1944
Oil on canvas
40.6 × 50.8 cm
(15 ¾ × 19 ¾ inches)
Presented by the Contemporary Arts Society 1945
Tate

Paul Graham

from *Beyond Caring*
Woman in Headscarf, DHSS Waiting Room, Bristol 1984
Colour coupler print
88.5 × 106 cm
(34 ½ × 41 ¼ inches)
Courtesy of the artist and Anthony Reynolds Gallery, London

from *Beyond Caring*
Queue, Paddington DHSS West London 1985
Colour coupler print
88.5 × 106 cm
(34 ½ × 41 ¼ inches)
Courtesy of the artist and Anthony Reynolds Gallery, London

John Grierson

Drifters 1929
16mm film transferred to DVD
b/w 41 mins
British Film Institute, National Film and Television Archive

Granton Trawler 1934
35mm film transferred to DVD
b/w 10 mins
British Film Institute, National Film and Television Archive

Richard Hamilton

The citizen 1981–3
Oil on canvas
support (1): 200 × 100 cm
(78 × 39 inches)
support (2): 200 × 100 cm
(78 × 39 inches)
frame: 206.7 × 210.2 × 3.2 cm
(80 ½ × 82 × 1 ¼ inches)
Purchased 1985
Tate

Edith Tudor Hart

Illustration for the National Unemployed Workers Movement Agitational Pamphlet c.1930s
Black and white photograph (modern print)
40.6 × 30.5 cm (16 × 12 inches)
Open Eye Gallery, Liverpool

Miner's relaxing after shift c.1930s
Black and white photograph (modern print)
40.6 × 30.5 cm (16 × 12 inches)
Open Eye Gallery, Liverpool

Worker in a Cement Factory, Cheadle 1947
Black and white photograph (modern print)
40.6 × 30.5 cm (16 × 12 inches)
Open Eye Gallery, Liverpool

Demonstration, South Wales c.1930s
Black and white photograph (modern print)
35.5 × 30.5 cm (14 × 12 inches)
Open Eye Gallery, Liverpool

No Home, No Dole, London c.1934
Black and white photograph (modern print)
50.8 × 40.6 cm (20 × 16 inches)
Open Eye Gallery, Liverpool

Nick Hedges

Disabled mother and son living in slum housing, All Saints 1968
Black and white photograph
33.7 × 50.2 cm (13 × 19 ½ inches)
Courtesy of Birmingham Central Library

Greta and daughter, doorway of a condemned property, Ladywood 1968
Black and white photograph
31.6 × 22.9 cm (12 ¼ × 9 inches)
Courtesy of Birmingham Central Library

Mother discussing housing conditions, Moseley June 1969
Black and white photograph
25.4 × 20.3 cm (10 × 8 inches)
Courtesy of Birmingham Central Library

View into the outside lavatory March 1969
Black and white photograph
25.4 × 20.3 cm (10 × 8 inches)
Courtesy of Birmingham Central Library

Mother and children, Balsall Heath January 1969
Black and white photograph
20.3 × 25.4 cm (8 × 10 inches)
Courtesy of Birmingham Central Library

Kitchen in council owned slum property in Hampden Street, Balsall Heath November 1969
Black and white photograph
20.3 × 25.4 cm (8 × 10 inches)
Courtesy of Birmingham Central Library

Two boys, one holding a car tyre, walking along the road May 1969
Black and white photograph
20.3 × 25.4 cm (8 × 10 inches)
Courtesy of Birmingham Central Library

Bradford May 1969
Black and white photograph
20.3 × 25.4 cm (8 × 10 inches)
Courtesy of Birmingham Central Library

View over back gardens and backs of houses, Bradford May 1969
Black and white photograph
20.3 × 25.4 cm (8 × 10 inches)
Courtesy of Birmingham Central Library

Occupied three-storey house, with derelict properties on either side, Liverpool March 1969
Black and white photograph
20.3 × 25.4 cm (8 × 10 inches)
Courtesy of Birmingham Central Library

Bradford May 1969
Black and white photograph
20.3 × 25.4 cm (8 × 10 inches)
Courtesy of Birmingham Central Library

Nigel Henderson

Newsagent in Bethnal Green Road c.1952
Silver gelatine print
20.2 × 25.3 cm (8 × 10 inches)
Lent by the Museum of London

Jewish street vendor, Bethnal Green Road c.1950–52
Silver gelatine print
25.3 × 20.2 cm (10 × 8 inches)
Lent by the Museum of London

Family Group on the Thames Embankment c.1952
Silver gelatine print
20.3 × 25.3 cm (8 × 10 inches)
Lent by the Museum of London

Penny for the Guy, East London c.1950–52
Silver gelatine print
20.6 × 25.5 cm (8 × 10 inches)
Lent by the Museum of London

Wig Stall, Petticoat Lane 1952
Silver gelatine print
25.4 × 20.3 cm (10 × 8 inches)
The Mayor Gallery

Peter Samuels 1951
Silver gelatine print
25.4 × 20.3 cm (10 × 8 inches)
The Mayor Gallery

Coronation Day Celebrations, Bethnal Green 1953
Silver gelatine print
25.4 × 20.3 cm (10 × 8 inches)
The Mayor Gallery

Coronation Day celebrations, Bethnal Green 1953
Silver gelatine print
25.4 × 20.3 cms (10 × 8 inches)
The Mayor Gallery

Untitled (study for 'Parallel of Life and Art') 1952
Black and white photographs, pen and pencil on card
21.6 × 30.5 cm (8 ½ × 12 inches)
The Mayor Gallery

Humphrey Jennings

Allotments, Bolton c.1944–45
Oil on canvas
43.8 × 53.3 cm (17 ¼ × 21 inches)
Bolton Museums, Art Gallery and Aquarium, Bolton MBC

Listen to Britain 1942
35/16 mm film transferred to DVD
b/w 20 mins
British Film Institute, National Film and Television Archive

Isaac Julien

Territories 1984
16 mm film transferred to DVD
col 25 mins
Courtesy of Isaac Julien

Paradise Omeros 2002
16 mm film transferred to DVD
col 20 minutes, 29 seconds
Courtesy of Isaac Julien

Patrick Keiller

London 1993
35mm film transferred to DVD
col 84 mins
British Film Institute, National Film and Television Archive

Chris Killip

Youth on Wall, Jarrow, Tyneside 1976
Silver bromide photograph
50.8 × 61 cm (20 × 24 inches)
Courtesy of the artist

West End, Newcastle-upon-Tyne, Tyneside 1980
Silver bromide photograph
61 × 50.8 cm (24 × 20 inches)
Courtesy of the artist

Rocker and Rosie, Lynemouth, Northunberland 1984
Silver bromide photograph
50.8 × 61 cm (20 × 24 inches)
Courtesy of the artist

Helen and Hula-hoop, Lynemouth, Northunberland 1984
Silver bromide photograph
50.8 × 61 cm (20 × 24 inches)
Courtesy of the artist

Angelic Upstarts, Sunderland 1984
Silver bromide photograph
50.8 × 61 cm (20 × 24 inches)
Courtesy of the artist

Sirkka-Liisa Konttinen

from *Byker*
Girl and child, Janet Street backlane 1971
Black and white photograph
16.5 × 29.5 cm (9 ½ × 6 ½ inches)
Side Gallery, Newcastle

from *Byker*
Kids playing house with collected junk near Byker Bridge 1971
Black and white photograph
16.5 × 29.5 cm (9 ½ × 6 ½ inches)
Side Gallery, Newcastle

from *Byker*
Girl on a 'spacehopper', Janet Street backlane 1971
Black and white photograph
29.5 × 16.5cm (9 ½ × 6 ½ inches)
Side Gallery, Newcastle

from *Byker*
Fooling around in the backyard, Oban Road 1975
Black and white photograph
16.5 × 29.5 cm (9 ½ × 6 ½ inches)
Side Gallery, Newcastle

from *Byker*
Isaac in front of his shop 1974
Black and white photograph
16.5 × 29.5 cm (9 ½ × 6 ½ inches)
Side Gallery, Newcastle

from *Byker*
Kendal Street 1969
Black and white photograph
16.5 × 29.5 cm (9 ½ × 6 ½ inches)
Side Gallery, Newcastle

from *Byker*
Willie Neilson, St Lawrence Square 1971
Black and white photograph
16.5 × 29.5 cm (9 ½ × 6 ½ inches)
Side Gallery, Newcastle

from *Byker*
Heather playing the piano in a derelict house 1971
Black and white photograph
16.5 × 29.5 cm (9 ½ × 6 ½ inches)
Side Gallery, Newcastle

from *Byker*
Jimmy gesturing in the street 1971
Black and white photograph
16.5 × 29.5 cm (9 ½ × 6 ½ inches)
Side Gallery, Newcastle

Ken Loach

Cathy Come Home 1966
16mm film transferred to DVD
b/w 77 mins
British Film Institute, National Film and Television Archive

Mary Kelly, Margaret Harrison and Kay Hunt

Women and Work: A Document on the Division of Labour in Industry, 1973–75
Mixed media
Display dimensions variable
Purchased 2001
Tate

Norman McLaren

Hell Unltd 1936
16mm film transferred to DVD
b/w 15 mins
British Film Institute, National Film and Television Archive

Roger Mayne

Children around a lorry, Cowcaddens, Glasgow 1958
Silver gelatine print
27.9 × 38.1 cm (11 × 15 inches)
Courtesy of Roger Mayne

Dublin 1957
Silver gelatine print
45.1 × 33.6 cm (17 ¾ × 13 ¼ inches)
Courtesy of Roger Mayne

Southam Street 5 May 1956
Silver gelatine print
24.8 × 32.4 cm (9 ¾ × 12 ¾ inches)
Courtesy of Roger Mayne

*Handstand, Southam Street,
North Kensington, London* 1957
Silver gelatine print
30.5 × 22.9 cm (12 × 9 inches)
Courtesy of Roger Mayne

Southam Street, North Kensington
1959
Silver gelatine print
28.6 × 36.8 cm (11 ¼ × 14 ½ inches)
Courtesy of Roger Mayne

The Gorbals, Glasgow 1958
Silver gelatine print
33 × 43.2 cm (13 × 17 inches)
Courtesy of Roger Mayne

Princedale Road, North Kensington
1956
Silver gelatine print
33.7 × 45.1 cm (13 ¼ × 17 ¾ inches)
Courtesy of Roger Mayne

Southam Street 1958
Silver gelatine print
41.9 × 33 cm (16 ½ × 13 inches)
Courtesy of Roger Mayne

*Girl on the steps, St Stephen's
Gardens, Westbourne Park* 1957
Black and white photograph
34.3 × 22.9 cm (13 ½ × 9 inches)
Courtesy of Roger Mayne

Goalie, Brindley Road, Paddington
1956
Black and white photograph
40 × 30.5 cm (15 ¾ × 12 inches)
Courtesy of Roger Mayne

*West Indians, Southam Street,
North Kensington, London* 1956
Black and white photograph
43.2 × 48.4 cm (17 × 23 inches)
Courtesy of Roger Mayne

*Girl Jiving, Southam Street,
North Kensington* 1957
Black and white photograph
34.3 × 22.9 cm (13 ½ × 9 inches)

Courtesy of Roger Mayne
Throgmorton Street, City 1960
Black and white photograph
27.9 × 42.5 cm (11 × 16 ¾ inches)
Courtesy of Roger Mayne

Teddy Girls, Battersea Fun Fair
1956
Black and white photograph
34.9 × 26.7 cm
(13 ¾ × 10 ½ inches)
Courtesy of Roger Mayne

*Teddy Boy and Girl,
Petticoat Lane* 1956
Black and white photograph
24.1 × 36.8 cm (9 ½ × 14 ½ inches)
Courtesy of Roger Mayne

*Boys Smoking, Portland Road,
North Kensington* 1956
Black and white photograph
34.9 × 25.4 cm (13 ¾ × 10 inches)
Courtesy of Roger Mayne

*Women, Southam Street,
North Kensington, London* 1961
Black and white photograph
38.1 × 57.2 cm (15 × 22 ½ inches)
Courtesy of Roger Mayne

Henry Moore

Grey Tube Shelter 1940
Watercolour, gouache and
drawing on paper
27.9 × 38.1 cm (15 × 11 inches)
Presented by the War Artists
Advisory Committee 1946
Tate

Women and Children in the Tube
1940
Chalk and wash on paper
27.9 × 38.1 cm (11 × 15 inches)
Imperial War Museum, London

*At the Coal Face. A miner pushing
a tub* 1942
Ink and chalk on paper
32 × 65 cm (12 ½ × 25 ½ inches)
Imperial War Museum, London

A Miner at Work 1942
Ink, chalk and gouache on paper
49.5 × 49.5 cm
(19 ½ × 19 ½ inches)
Imperial War Museum, London

Horace Ové

Pressure 1975
16/35mm film transferred to DVD
col 110 mins
British Film Institute, National Film
and Television Archive

*Stokely Carmichael addressing
the Black Power Conference,
The Roundhouse, Camden* 1967
Black and white photograph
61 × 86 cm (24 × 33 ¾ inches)
Courtesy of Horace Ové

*Michael X and Members of
the Black Power movement at
Paddington Station* 1968
Black and white photograph
56 × 86 cm (22 × 33 ¾ inches)
Courtesy of Horace Ové

Walking Proud, London mid 1970s
Colour photograph
73 × 86 cm (28 ¾ × 33 ¾ inches)
Courtesy of Horace Ové

Two Generations, Notting Hill
mid 1970s
Colour photograph
58 × 87 cm (22 ¾ × 34 ¼ inches)
Courtesy of Horace Ové

Darcus Howe, The Mangrove Nine
March 1970s
Black and white photograph
59 × 86 cm (23 ¼ × 33 ¾ inches)
Courtesy of Horace Ové

*Under Heavy Manners (Roy Sawh
arrest)* 1970s
Black and white photograph
41 × 61 cm (16 ¼ × 24 inches)
Courtesy of Horace Ové

Black Man in Suit at Demo 1970s
Black and white photograph
41 × 61 cm (16 ¼ × 24 inches)
Courtesy of Horace Ové

Martin Parr

The Last Resort 23 1983–6,
printed 2002
Colour photograph on
photographic paper
image: 104 × 132 cm
(41 × 52 inches)
Purchased from the Rocket Press
(General Funds) 2002
Tate

The Last Resort 25 1983–6,
printed 2002
C-type print
image: 104 × 132 cm
(41 × 52 inches)
Purchased from the Rocket Press
(General Funds) 2002
Tate

Keith Pattison

*Durham coastline looking south
from Easington Colliery to winding
gears at Blackhall and Horden.*
August 1984
Black and white photograph
33 × 48.3 cm (13 × 19 inches)
Courtesy of the artist

*Distributing food parcels.
Easington Miners Welfare Hall.
Easington Colliery, Co. Durham.*
August 1984
Black and white photograph
33 × 48.3 cm (13 × 19 inches)
Courtesy of the artist

*Families of striking miners look on
as police seal off the pit and escort
the first returning miner back to
work. Easington Colliery, Co.
Durham* 24th August 1984
Black and white photograph
33 × 48.3 cm (13 × 19 inches)
Courtesy of the artist

*A shove and a heave at the pit
gates. Easington Colliery, Co.
Durham* 20th August 1984
Black and white photograph
33 × 48.3 cm (13 × 19 inches)
Courtesy of the artist

*Arrest of Josie Smith, a retired,
disabled miner, during police
efforts to escort returning miners
back to work. Easington Colliery,
Co. Durham* December 1984
Black and white photograph
33 × 48.3 cm (13 × 19 inches)
Courtesy of the artist

*Police seal off the pit gates and
escort the first returning miner
back to work. Easington Colliery,
Co. Durham* 24th August 1984.
Black and white photograph
33 × 48.3 cm (13 × 19 inches)
Courtesy of the artist

William Raban

Thames Film 1986
16 mm film transferred to DVD
col. 66 mins
Courtesy of the artist/LUX

Island Race 1996
Video transferred to DVD
col. 28 mins
Courtesy of the artist/LUX

Tony Ray-Jones

Glyndebourne Festival 1967
Modern black and white copy
print from original negative
Frame size 40.6 × 50.8 cm
(16 × 20 inches)
National Museum of Photography,
Film and Television, Bradford

Ramsgate 1967
Modern black and white copy
print from original negative
Frame size 40.6 × 50.8 cm
(16 × 20 inches)
National Museum of Photography,
Film and Television, Bradford

Blackpool 1968
Modern black and white copy
print from original negative
Frame size 40.6 × 50.8 cm
(16 × 20 inches)
National Museum of Photography,
Film and Television, Bradford

Brighton Beach 1966
Modern black and white copy
print from original negative
Frame size 40.6 × 50.8 cm
(16 × 20 inches)
National Museum of Photography,
Film and Television, Bradford

Dickens Festival, Broadstairs
1967–68
Modern black and white copy
print from original negative
Frame size 40.6 × 50.8 cm
(16 × 20 inches)
National Museum of Photography,
Film and Television, Bradford

Thaxted Unicorn and Morris Men
1966
Modern black and white copy
print from original negative
Frame size 40.6 × 50.8 cm
(16 × 20 inches)
National Museum of Photography,
Film and Television, Bradford

Durham Miners' Gala 1969
Modern black and white copy
print from original negative
Frame size 40.6 × 50.8 cm
(16 × 20 inches)
National Museum of Photography,
Film and Television, Bradford

Eton 1967
Modern black and white copy
print from original negative
Frame size 40.6 × 50.8 cm
(16 × 20 inches)
National Museum of Photography,
Film and Television, Bradford

Crufts Dog Show 1968
Vintage black and white print
Frame size 40.6 × 50.8 cm
(16 × 20 inches)
National Museum of Photography,
Film and Television, Bradford

Clacton 1967
Modern black and white copy
print from original negative
Frame size 30.5 × 40.6 cm
(12 × 16 inches)
National Museum of Photography,
Film and Television, Bradford

Waxworks, Eastbourne 1968
Modern black and white copy
print from original negative
Frame size 40.6 × 50.8 cm
(16 × 20 inches)
National Museum of Photography,
Film and Television, Bradford

Karel Reisz

We Are the Lambeth Boys 1959
16mm film transferred to DVD
b/w 52 mins
British Film Institute, National Film
and Television Archive

Jack Smith

Mother Bathing Child 1953
Oil on board
182.9 × 121.9 cm (72 × 48 inches)
Purchased 1955
Tate

Stanley Spencer

Shipbuilding on the Clyde: Burners.
National Gallery Print
Lithograph on paper
76.5 × 102 cm (30 × 40 inches)
Imperial War Museum, London

William McBrearty, Sawyer 1943–4
Drawing on paper
support: 48.9 × 39.4 cm
(19 1/4 × 15 1/2 inches)
Presented by the War Artists
Advisory Committee 1946
Tate

Humphrey Spender

*Panorama – Central Bolton from
Mere Hall Art Gallery* c.1937–8
Black and white photograph
Dimensions sight size:
23 × 35cm (9 × 13 3/4 inches)
Bolton Museums, Art Gallery and
Aquarium, Bolton MBC

Washing Line c.1937–8
Black and white photograph
Dimensions sight size:
25.9 × 35.7 cm (10 1/4 × 14 inches)
Bolton Museums, Art Gallery and
Aquarium, Bolton MBC

*On the roof, Mere Hall, William
Coldstream Painting* c.1937–8
Black and white photograph
Dimensions sight size:
11.5 × 17.0cm (4 1/2 × 6 3/4 inches)
Bolton Museums, Art Gallery and
Aquarium, Bolton MBC

*On the roof, Mere Hall, Tom
Harrison* c.1937–8
Black and white photograph
Dimensions sight size:
10.7 × 15.0cm (4 1/4 × 6 inches)
Bolton Museums, Art Gallery and
Aquarium, Bolton MBC

*On the roof, Mere Hall, Bolton
Rooftops* c.1937–8
Black and white photograph
Dimensions sight size:
11.6 × 17.5cm (4 1/2 × 6 3/4 inches)
Bolton Museums, Art Gallery and
Aquarium, Bolton MBC

Interior – Textile Mills c.1937–8
Black and white photograph
Dimensions sight size:
25.7 × 35.2 cm (10 × 13 3/4 inches)
Bolton Museums, Art Gallery and
Aquarium, Bolton MBC

Inside the Mill c.1937–8
Black and white photograph
19.1 × 12.0cm (7 1/2 × 4 3/4 inches)
Bolton Museums, Art Gallery and
Aquarium, Bolton MBC

Pub c.1937–8
Black and white photograph
17.8 × 12.7 cm (7 × 5 inches)
Bolton Museums, Art Gallery and
Aquarium, Bolton MBC

Ashington Miner's Artgroup
c.1937–8
Black and white photograph
11.7 × 19.0 cm (7 1/2 × 4 1/2 inches)
Bolton Museums, Art Gallery and
Aquarium, Bolton MBC

*Employment Exchange – Queue
of Unemployed* c.1937–8
Black and white photograph
12.7 × 17.8 cm (5 × 7 inches)
Bolton Museums, Art Gallery and
Aquarium, Bolton MBC

Street Life – Children at Play
c.1937–8
Black and white photograph
17.8 × 12.7 cm (7 × 5 inches)
Bolton Museums, Art Gallery and
Aquarium, Bolton MBC

Blackpool – Olympia Prizes
c.1937–8
Black and white photograph
Dimensions sight size:
23.8 × 17.0 cm (9 1/4 × 6 3/4 inches)
Bolton Museums, Art Gallery and
Aquarium, Bolton MBC

Blackpool Illuminations c.1937–8
Black and white photograph
17.8 × 12.7 cm (7 × 5 inches)
Bolton Museums, Art Gallery and
Aquarium, Bolton MBC

Blackpool Lights – Street
Illuminations c.1937–8
Black and white photograph
17.9 × 24.6 cm (7 × 9 3/4 inches)
Bolton Museums, Art Gallery and
Aquarium, Bolton MBC

Railway Station – Waiting for Train
c.1937–8
Black and white photograph
12.7 × 17.8 cm (5 × 7 inches)
Bolton Museums, Art Gallery and
Aquarium, Bolton MBC

Industrial Scene – Textile Mills
c.1937–8
Black and white photograph
17.8 × 12.7 cm (7 × 5 inches)
Bolton Museums, Art Gallery and
Aquarium, Bolton MBC

Industrial Landscape – Back of
Mills c.1937–8
Black and white photograph
12.7 × 17.8 cm (5 × 7 inches)
Bolton Museums, Art Gallery and
Aquarium, Bolton MBC

Back to Back Housing perspective
c.1937–8
Black and white photograph
12.7 × 17.8 cm (5 × 7 inches)
Bolton Museums, Art Gallery and
Aquarium, Bolton MBC

Bye-election Hoarding c.1937–8
Black and white photograph
12.7 × 17.8 cm (5 × 7 inches)
Bolton Museums, Art Gallery and
Aquarium, Bolton MBC

Bye-election Poster c.1937–8
Black and white photograph
17.8 × 12.7 cm (7 × 5 inches)
Bolton Museums, Art Gallery and
Aquarium, Bolton MBC

Open Market – Palmist c.1937–8
Black and white photograph
17.8 × 12.7 cm (7 × 5 inches)
Bolton Museums, Art Gallery and
Aquarium, Bolton MBC

Cafe Counter – 'Try our ices
1d & 6d' c.1937–8
Black and white photograph
12.7 × 17.8 cm (5 × 7 inches)
Bolton Museums, Art Gallery and
Aquarium, Bolton MBC

Domestic Interior c.1937–8
Black and white photograph
Dimensions sight size:
23 × 35 cm (9 × 13 3/4 inches)
Bolton Museums, Art Gallery and
Aquarium, Bolton MBC

Pub Interior – Dart Practice
c.1937–8
Black and white photograph
12.7 × 17.8 cm (5 × 7 inches)
Bolton Museums, Art Gallery and
Aquarium, Bolton MBC

Pub Interior c.1937–8
Black and white photograph
12.7 × 17.8 cm (5 × 7 inches)
Bolton Museums, Art Gallery and
Aquarium, Bolton MBC

MO House c.1937–8
Black and white photograph
24.2 × 30.2cm (9 1/2 × 11 3/4 inches)
Bolton Museums, Art Gallery and
Aquarium, Bolton MBC

Blackpool: Sideshows c.1937–8
Black and white photograph
19.2 × 12.2cm (7 1/2 × 4 3/4 inches)
Bolton Museums, Art Gallery and
Aquarium, Bolton MBC

Blackpool: Display Window,
Waxworks c.1937–8
Black and white photograph
18.7 × 12.0cm (7 1/4 × 4 3/4 inches)
Bolton Museums, Art Gallery and
Aquarium, Bolton MBC

Street Scene: Children Playing
with Chicken Claws c.1937–8
Black and white photograph
Dimensions sight size:
10.9 × 17.0 cm (4 1/4 × 6 3/4 inches)
Bolton Museums, Art Gallery and
Aquarium, Bolton MBC

Women washing and wringing
out clothes in the backyard of
a house in Whitechapel c.1930s
Silver gelatine print
29 × 39.3 cm (11 1/2 × 15 1/2 inches)
Lent by the Museum of London

Young couple having tea at
home in Whitechapel c.1930s
Silver gelatine print
30 × 40.2mm (11 3/4 × 15 3/4 inches)
Lent by the Museum of London

Woman busker carrying street
organ from a pub in Whitechapel
c.1937–8
Silver gelatine print
39.2 × 29 cm (15 1/2 × 11 1/2 inches)
Lent by the Museum of London

Pram ride in the park (Kensington
Park Gardens) c.1930s
Silver gelatine print
30 × 40.4 cm (11 3/4 × 16 inches)
Lent by the Museum of London

Wolfgang Suschitzky

Lyons Corner House, Tottenham
Court Road c.1934
Silver gelatine print
23.1 × 29.4 cm (9 × 11 1/2 inches)
Lent by the Museum of London

Bishops Bridge Road, Paddington,
London 1935
Silver gelatine print
23.3 × 29 cm (9 × 11 1/2 inches)
Lent by the Museum of London

Victoria Bus Station 1939
Silver gelatine print
23.4 × 30 cm (9 1/4 × 11 3/4 inches)
Lent by the Museum of London

Waterloo Bridge Builders Union
Meeting August 1939
Silver gelatine print
23.3 × 30 cm (9 1/4 × 11 3/4 inches)
Lent by the Museum of London

Julian Trevelyan

The Potteries c.1938
Oil on canvas
60.4 × 73.5 cm
(23 3/4 × 28 3/4 inches)
Presented by Mary Trevelyan,
the artist's widow 1996
Tate

Teapot Café c.1937–8
Black and white photograph
16.5 × 21.5 cm (6 1/2 × 8 1/2 inches)
Bolton Museums, Art Gallery and
Aquarium, Bolton MBC

Puppet Show c.1937–8
Black and white photograph
21.5 × 16.5 cm (8 1/2 × 6 1/2 inches)
Bolton Museums, Art Gallery and
Aquarium, Bolton MBC

Fish and Chip Shop c.1937–8
Black and white photograph
16.4 × 21.5 cm (6 1/2 × 8 1/2 inches)
Bolton Museums, Art Gallery and
Aquarium, Bolton MBC

Hoyle's Bed and Breakfast c.1937–8
Black and white photograph
16.4 × 21.5 cm (6 1/2 × 8 1/2 inches)
Bolton Museums, Art Gallery and
Aquarium, Bolton MBC

People in costume c.1937–8
Black and white photograph
16.6 × 21.7 cm (6 1/2 × 8 1/2 inches)
Bolton Museums, Art Gallery and
Aquarium, Bolton MBC

'The Sinister 6' c.1937–8
Black and white photograph
16.6 × 21.7 cm (6 1/2 × 8 1/2 inches)
Bolton Museums, Art Gallery and
Aquarium, Bolton MBC

Amusement Arcade: The Twins
c.1937–8
Black and white photograph
sight size: 19.7 × 14.4 cm
(7 3/4 × 5 1/2 inches)
Bolton Museums, Art Gallery and
Aquarium, Bolton MBC

Industrial Landscape c.1937–8
Black and white photograph
16.5 × 21.6 cm (6 1/2 × 8 1/2 inches)
Bolton Museums, Art Gallery and
Aquarium, Bolton MBC

Allotments c.1937–8
Black and white photograph
16.6 × 21.6 cm (6 1/2 × 8 1/2 inches)
Bolton Museums, Art Gallery and
Aquarium, Bolton MBC

Industrial Landscape c.1937–8
Black and white photograph
16.6 × 21.6 cm (6 1/2 × 8 1/2 inches)
Bolton Museums, Art Gallery and
Aquarium, Bolton MBC

List of exhibited works

Industrial Landscape c.1937–8
Black and white photograph
16.5 × 21.5 cm (6 ½ × 8 ½ inches)
Bolton Museums, Art Gallery and
Aquarium, Bolton MBC
Art Classes c.1937–8
Black and white photograph
16.4 × 21.5 cm (6 ½ × 8 ½ inches)
Bolton Museums, Art Gallery and
Aquarium, Bolton MBC

Art Classes c.1937–8
Black and white photograph
16.4 × 21.5 cm (6 ½ × 8 ½ inches)
Bolton Museums, Art Gallery and
Aquarium, Bolton MBC

Paul Watson and
Franc Roddam

The Family 1974
16mm film transferred to DVD
col 29mins
British Film Institute, National Film
and Television Archive

Basil Wright

Song of Ceylon 1935
16mm film transferred to DVD
b/w 40 mins
British Film Institute, National Film
and Television Archive

Gillian Wearing

10 – 16 1997
Video
Display dimensions variable
Presented by the Patrons of
New Art through the Tate Gallery
Foundation 1998
Tate

'I like to be in the country' 1992–3
Colour photograph on paper
122 × 92 cm (48 × 36 ¼ inches)
Purchased 2000
Tate

*'I signed on and they would
not give me nothing'* 1992–3
Colour photograph on paper
122 × 92 cm (48 × 36 ¼ inches)
Purchased 2000
Tate

*'Everything is connected in
life…'* 1992–3
Colour photograph on paper
122 × 92 cm (48 × 36 ¼ inches)
Purchased 2000
Tate

Images Copyright

40, 48 © Royal Mail Film Archive; 14, 38, 44, 62, 70, 85 © British Film Institute, National Film and Television Archive; 76 © Producer / Director Paul Watson; 10, 41 © Crown Copyright / Film Images; 19 © Vanley Burke Archive, Birmingham Central Library; 70 © Courtesy of Birmingham Central Library; 8, 33, 62, 63 © Humphrey Spender / Bolton Museums, Art Gallery & Aquarium (MBC); 78 © John Davies 1983; Cover Image © Roger Mayne; 80 © The artist © Jerry Hardman-Jones; 82, 88 © The artist, courtesy Anthony Reynolds Gallery; 90 © Nathan Coley 2005, courtesy Haunch of Venison, London; 2, 50, 53, 55, 59, 67 © Bill Brandt Archive Ltd; 29 © Imperial War Museum, London; 81 © William Raban / LUX; 16, 68, 72 © Roger Mayne / Museum of London; 62 © Trevelyan Estate; 65 © W. Suschitzky; 73 © NMPFT / Science & Society Picture Library; 23, 64 © Edith Tudor Hart; 43 © Amber; 79 © Keith Pattison; 84 © Konttinen / Amber; 66 © The Henry Moore Foundation; 74 © Estate of the Artist; 83 © Richard Hamilton 2002. All rights reserved, DACS; 21 © Gilbert and George; 77 © Margaret Harrison, Mary Kelly and the Estate of Kay Fido; 47 © Martin Jenkinson; 91 © Deller/Figgis / The Modern Institute Glasgow © Serge Hasenböhler, CH-Basel; 72 © The Henderson Estate c/o the Mayor Gallery; 69 © Lucian Freud; 23, 92 © The artist and Maureen Paley, London; 87 © Martin Parr © Magnum Photos / Rocket Gallery; 31 © Estate of the Artist; 71 © The Artist; 89 © Willie Doherty; 75 © James Hyman Fine Art, on behalf of the Estate of Michael Andrews; 46, 93 © Isaac Julien, courtesy Victoria Miro Gallery, London; 86 © The Artist; 32 © Yale Center for British Art, Paul Mellon Fund; 26 © Private Collection/Bridgeman Art Library © Harry Ransom Humanities Research Center The University of Texas at Austin; 33 © Private Collection/Bridgeman Art Library © National Gallery of Canada

Disclaimer: Should, despite intensive research any person entitled to rights have been overlooked, legitimate claims shall be compensated within the usual provisions.